IMAGES
of America

ST. AUGUSTINE

This book is dedicated in loving memory to Lucy,
who gave me spirit,
and to Jessie,
who gave me life.

On the cover: In the late 1800s, 70 Native Americans from the Western Frontier were transported via rail to Fort Marion in St. Augustine, as it was determined they were a danger to peace efforts and needed to be incarcerated far from home. Although the Americans captured their lives, these imprisoned men and women determined to capture their history. Using colored pencils, they drew for future generations how they lived while at Fort Marion. Sometime during the middle of the 20th century, a great-grandson of one of the prisoners visited the fort during his military leave. Fort officials asked him to pose beside the ancient monument holding his ancestor's creation.

IMAGES
of America

ST. AUGUSTINE

Maggi Smith Hall
and the St. Augustine Historical Society

ARCADIA
PUBLISHING

Copyright © 2002 by Maggi Smith Hall and the St. Augustine Historical Society
ISBN 978-0-7385-1429-1

Published by Arcadia Publishing
Charleston, South Carolina

Printed in the United States of America

Library of Congress Catalog Card Number: 2002102022

For all general information contact Arcadia Publishing at:
Telephone 843-853-2070
Fax 843-853-0044
E-mail sales@arcadiapublishing.com
For customer service and orders:
Toll-Free 1-888-313-2665

Visit us on the Internet at www.arcadiapublishing.com

CONTENTS

ABOUT THE AUTHOR

Maggi Smith Hall is a native Floridian raised in Jacksonville. She received a B.A. from Stetson University in education with a minor in history and an M.A. in learning disabilities from Francis Marion University in South Carolina. During her 30 years as an educator, she took time from classroom teaching to establish and direct two educational institutions in South Carolina: The Marion County Museum and the Fork Retch Environmental Education Center. While a museum director, she also directed the South Carolina Rural Arts Program for Marion County.

For these endeavors she received local, state, and national recognition including the South Carolina State Archives Award for "Adaptive Restoration of an Historic Facility," the National 1993 Environmental Women of Action Award for South Carolina (presented by the National Wilderness Society in Washington, D.C.), and the 1995 Education Conservationist Award presented by the South Carolina Wildlife Federation.

As an environmentalist, she has been filmed for two national documentaries: *Conserving America: The Rivers,* for her work to preserve a South Carolina river, and *When A Tree Falls,* for her efforts to halt an interstate connector through wetlands. She was also interviewed in the July 1995 issue of *Southern Living.*

Since returning to Florida, Hall has been a freelance writer for newspapers in St. Augustine and DeLand. She has had articles published in several magazines and placed second in two national writing contests. In 1999, Tailored Tours Publications published her first book, *Flavors of St. Augustine: An Historic Cookbook.* At present, she is working on another St. Augustine book, as well as completing a lengthy book on teacher's rights as citizens.

She is an avid preservationist, having restored a dozen historic properties, most recently, Judge Blount's 1924 home in DeLand, where she and her husband now reside. She is also restoring five downtown structures for rentals and a veterinary clinic.

While living in St. Augustine and selling real estate, she worked extensively with historic properties, eventually setting the comps in the historic district. After moving to DeLand in 1999, she initiated a million dollar urban renewal project in a drug-ridden neighborhood of architecturally significant buildings. To date, over 50 structures are in various stages of restoration.

Maggi owns West Volusia Properties, a real estate firm whose motto is "Real Estate with a Personal Touch." She sits on the City of DeLand's Code Enforcement Board and is a member of numerous community organizations. She is married to Ronald, a philosophy professor at Stetson University. Their family includes two daughters and their husbands, three grandsons, and two dogs.

ACKNOWLEDGMENTS

The author wishes to express gratitude to the exuberant Executive Director of the St. Augustine Historical Society, Taryn Rodriguez-Boette, for her constant encouragement and gracious assistance. Her enthusiasm for protecting St. Augustine's cultural heritage and her ability to generate in others a love and commitment for this task is both applauded and appreciated. To Charles Tingley, St. Augustine Historical Society's Library Manager; Bill Temme, assistant librarian; and volunteer Marian Rogero for their conscientious pursuit of factual details, photocopying, and photographic additions, a hearty "Thank you!"

INTRODUCTION

The first known visual images of the land we now call Northeast Florida were created in 1564–1565 by Jacques Le Moyne, a French artist who accompanied Jean Ribault and René de Laudonnière on their voyage to the New World. Their ill-fated settlement, Fort Caroline, located at the mouth of the present-day St. Johns River near Jacksonville, lasted but a few years. However, Le Moyne's 42 drawings of the aborigines he met offer a remarkable and detailed account of life in La Florida before the impact of European migration.

At a time that seems primitive by modern standards, visual image-makers had been reproducing their likenesses, the images of their shelters, food, clothing, and natural surroundings for eons. They drew, painted, and carved in the dark recesses of caves, inside the labyrinths of pyramids, on papyrus, and on cliffs so lofty that contemporary man gazes in astonishment at their creative tenacity. They ingeniously used whatever materials nature afforded—charcoal, stone, metal, graphite, berry and bark juice, sand, and clay.

As time marched forward, image-makers explored new ways to record visual forms. By 350 B.C., during the time of the Greek philosopher Aristotle, they were experimenting with visually capturing or duplicating their surroundings on some type of material using a device based on the function of today's camera. This invention, eventually perfected in the early 1500s by Leonardo da Vinci, was named a camera obscura or "dark chamber."

Although the camera obscura was in existence during the time that the Spanish explorer Juan Ponce de León discovered the Florida peninsula in April 1513, he did not have access to such a device; neither did he have an artist accompanying him, as did Ribault. It would be de León's naming of his discovery and his descriptive words that allowed Europeans to see mentally or "picture" his discovery. He named this land "La Pasqua de Florida"—Pasqua for "Easter" and La Florida for "The Flowery Land." He explained his choice thus: "because it was very pretty to behold with many refreshing trees."

A year after Ribault's settlement was founded, Spain's King Phillip II commissioned Pedro Menéndez de Avilés to "explore and colonize La Florida," driving out settlers not subject to the Crown. By September 1565, Menéndez and hundreds of soldiers and settlers were sailing north along the coast of La Florida. Sighting a protected bay teeming with dolphins, Menéndez and his crew disembarked near the Timucuan Indian village of Seloy. He ordered a Spanish flag and cross to be placed in the sand, boldly proclaiming this land for his king. In honor of the Catholic Saint, Augustine, Menéndez named his new settlement San Agustín.

As life in San Agustín moved arduously forward, little attempt was made to record visually the images of this military outpost. Life during that first Spanish period (1565–1763) was too difficult to indulge in frivolous tasks such as drawing or painting. However, in Europe, image-makers persistently worked to improve the camera obscura.

By 1763, continued European conflict eventuated in La Florida being transferred to England. The image of this shift in ownership was recorded with pen and ink. In 1783, Florida was returned to Spain. However,

by the early 1800s, the new upstart country, the United States of America, was aggressively pursuing Spain's evacuation of its wilderness peninsula. In 1821, given an offer it could not refuse, Spain reluctantly agreed for the United States to pay Spain's international debts totaling $5 million in return for La Florida. On July 10, 1821, La Florida became a United States territory.

Although no American dabbled with inventing a mechanical image-making device, Europeans remained hard at work with their camera obscura, while events in America and St. Augustine continued to be documented visually with pen, ink, paints, paper, and canvas.

Five years after Florida became a part of the United States, Joseph Niépce, a Frenchman, successfully achieved a way to generate mechanically the eye's image and to make those images permanent. Niépce's procedure, called heliograph (from the Greek words helios for "sun," and graphos for "drawing"), captured images on a sheet of pewter. There remained a significant drawback with his process however—exposure time was eight hours. Since no one wanted to sit for a photographic session of such length, his picture taking entailed only fixed objects and scenery.

Niépce's invention peaked the curiosity of another Frenchman, Louis Daguerre, who had been experimenting with the Diorama or panoramic scenes re-created with the camera obscura, translucent paintings, and special lighting. After years of experimentation, Daguerre's new process of images captured on metal plates reduced exposure time from eight hours to thirty minutes. He also discovered that an image could be made permanent by immersing it in salt.

In January 1839, Daguerre announced his discovery, the daguerreotype, to the French Academy of Sciences. A French newspaper enthusiastically reported on his astounding image-capturing process: "What fineness in the strokes! What knowledge of chiaroscuro! What delicacy! What exquisite finish! How admirably are the foreshortenings given—this is Nature itself!"

Not everyone received the news of Daguerre's success with enthusiasm. The *Leipzig City Advertiser* criticized: "The wish to capture . . . reflections is not only impossible . . . but the mere desire alone, the will to do so, is blasphemy. God created man in His own image, and no manmade machine may fix the image of God. Is it possible that God should have abandoned his eternal principles, and allowed a Frenchman . . . to give to the world an invention of the Devil." Perhaps it was technological envy that provoked the German opinion—especially given that it was the French who had bested them—or perhaps it was simply the fear expressed by some artists that Daguerre's technique would negatively affect their profession. In any case, the fact remains that the centuries-old endeavor to capture an image permanently had been achieved. Although Daguerre's technique was an expensive once-only process, it encouraged continued improvement for a "manmade machine . . . [to] fix the image of God."

That same year, 1839, Englishman Sir John Herschel coined the word photography, derived from the Greek words photos, meaning "light," and graphien, meaning "to draw." This new word was later used to describe all processes by which the eye's image was mechanically recorded on some form of material.

Within months of Daguerre's discovery, William Talbot invented the calotype. This process allowed unlimited prints to be made from one sitting, the technique by which today's photographic principles is still based. Although the sitting time was greatly reduced and images were captured on paper, rather than on glass or tin, many felt the images were inferior to the daguerreotype. Indeed, by 1853, they were so immensely popular in America that an estimated three million daguerreotypes were produced annually.

A new process refined in 1851, called the collodion wet-plate, combined the best of the calotype with the best of the daguerreotype. Although the equipment was cumbersome, it increased image-making. Due to this new technique, photographers hailed a carriage or a train to travel the continent, taking their artistic talent into small communities to freeze—on glass or on tin—faces and landscapes.

Horse hooves and carriage wheels clamored along the corduroy road leading from Picolata to St. Augustine. Photographic equipment bounced precariously atop the coach. Passengers coughed, their eyes teared from dust churning through uncovered windows, but stalwart hearts beckoned them on. They were convinced that the 18-mile trip from the St. Johns River steamboat dock to the nation's oldest city would be worth the inconvenience. After all, since 1821, newspapers and magazines had praised the virtues of visiting the United States' newest territory and especially its eastern capital, St. Augustine.

Thus, after 300 years of people coming to town, the camera finally arrived.

One

THE SEASONAL RESIDENT

Pleasant salt breezes from the Atlantic Ocean, a mild climate, and boarding houses to accommodate the ill propelled the sick to St. Augustine after Florida became a United States territory. What unintentionally began as a venture in improving health eventually catapulted the city, as well as all of Florida, toward its most important economic venture—tourism.

Interestingly, a visitor to town was not dubbed a "tourist" until the 20th century. Before the early 1900s, visitors, whether ill or robust, were called "strangers." One such ailing stranger who wintered in St. Augustine in 1827 was Ralph Waldo Emerson, an aspiring writer. He kept a meticulous journal of his experiences, chronicling in one of his entries that the city was "full of ruins, chimneyless houses. Lazy people, housekeeping intolerably dear, and bad milk from swamp grass. . . ." He also saw the town's intrinsic beauty for he penned the following:

> The faint traces of romantic things
> The old land of America
> I find in this nook of sand
> The first footprints of that giant grown.

John James Audubon, the famous naturalist who visited Florida in 1832, vividly described his observations in his 1834 *Ornithological Biography*. In fact, no modern advertisement could compete with Audubon's glowing account of Florida's abundant natural offerings. His words peaked the curiosity of adventurers, causing them to travel south. He wrote, "Myriads of Cormorants covered the face of the waters. . . . [W]e found the vegetation already far advanced. The blossoms of the jessamine, ever pleasing, lay steeped in dew; the humming bee was collecting her winter's store from the snowy flowers of the native orange; and the little warblers frisked along the twigs of the smilax."

How could anyone not take the opportunity to experience such a natural wonderland? Stone buildings in various stages of decay, narrow dirt streets shaded by overhanging wooden or iron balconies, and a peaceful co-existence between man and nature irresistibly beckoned the fast-paced northerner toward a more gentle clime.

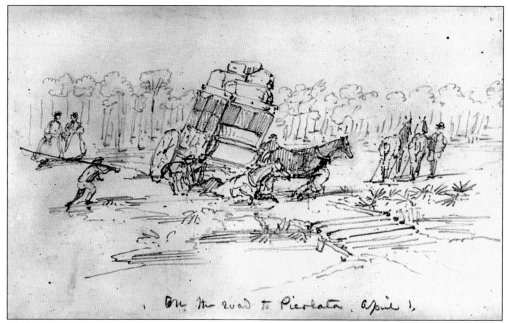

In the early 1800s, strangers from the north traveled a long precarious route to St. Augustine by steamship up the St. Johns River, then horse and buggy from the dock at Picolata into town. Sometimes they waited for hours, whether sick or healthy, until their ride appeared.

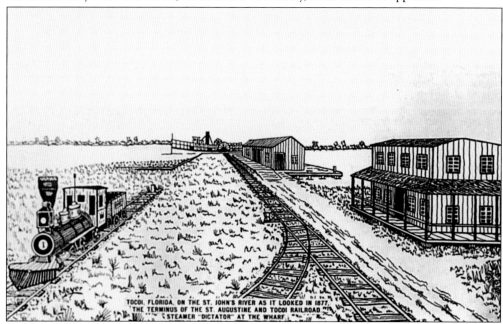

By the mid-1800s, visitors to town still steamed up the St. Johns from Jacksonville but disembarked at Tocoi, several miles south of Picolata. There, strangers hopped a "taxi" into town, a new vehicle that eliminated mud-flinging horses and tedious breakdowns. Blissfully relieved also was the painful body jarring from the washboard road that was so familiar to a traveler's anatomy. The slow, methodical grind of metal on metal as the passengers approached their destination offered a more relaxing and appreciated entry into town.

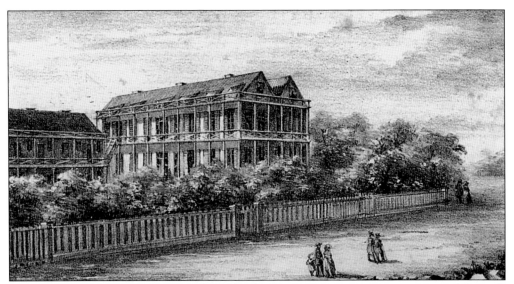

As more and more strangers arrived in placid St. Augustine to view its antiquated Spanish structures, take a stroll along the bay, or hire a boat to cross over the Matanzas River to wander the shore of the Atlantic, additional housing became necessary. In addition to several older hotels, the spacious Magnolia House was constructed in 1847. This grand dame, as well as other newly constructed hotels, soon replaced the numerous frame boarding houses that had sprung up after Florida became part of the United States.

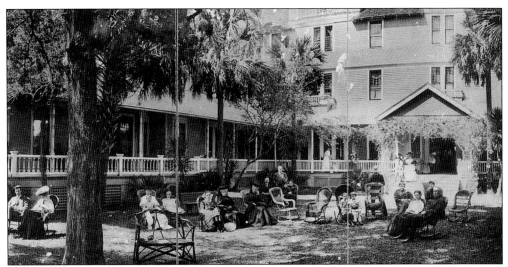

Seasonal residents relax on the grounds of the Magnolia after a morning of sightseeing, playing a game of golf or tennis, or having eaten a delicious luncheon. When visiting in St. Augustine, time seemed to stand still for these "strangers" from the north.

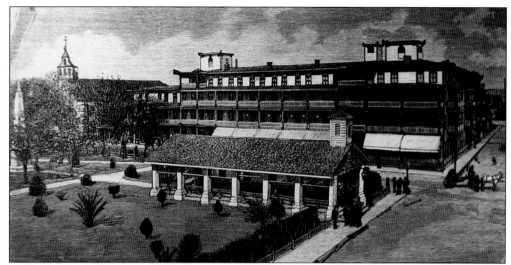

Ideally located on St. George Street north of the Plaza, the St. Augustine Hotel prided itself on its fine reputation as a grand house for wintering strangers. It accommodated over 40 people but by 1853 demand for additional rooms was so overwhelming that the hotel increased its size.

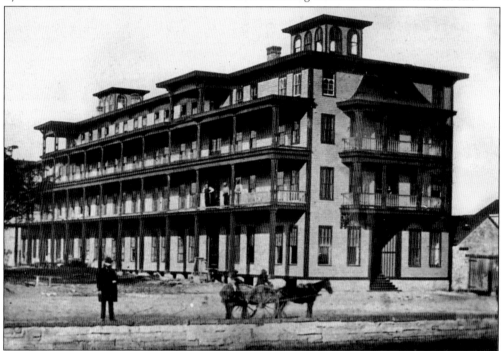

The Civil War put the brakes on winter visitors, but by 1869, four years after the war ended, the city boasted a new hotel—the St. Augustine. This new construction brought increased interest in visiting St. Augustine, so once again, northern strangers began steaming up the St. Johns River and then taxiing into town. After all, it was an easy choice to trade their harsh northern climate for paradise. One prominent guest to stay at the St. Augustine Hotel was Henry Morrison Flagler, the Standard Oil magnate from New York. That 1878 visit must have been to his liking, because he returned to St. Augustine a few years later and stayed in yet another new hotel, The San Marco, built in 1884.

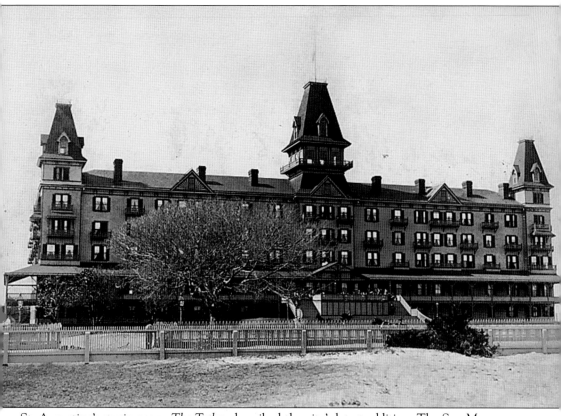

St. Augustine's gossip paper, *The Tatler*, described the city's latest addition, The San Marco, as standing "…on the highest point about the city…giving it the…most extensive view of the old fort, the bay, and as far as eye can see, the sweep of the ocean. The house stands in a park of fifteen acres…filled with roses and many varieties of tropical plants. The main entrance to the hotel is about twenty feet from the ground and reached by a long flight of stairs that give an imposing effect."

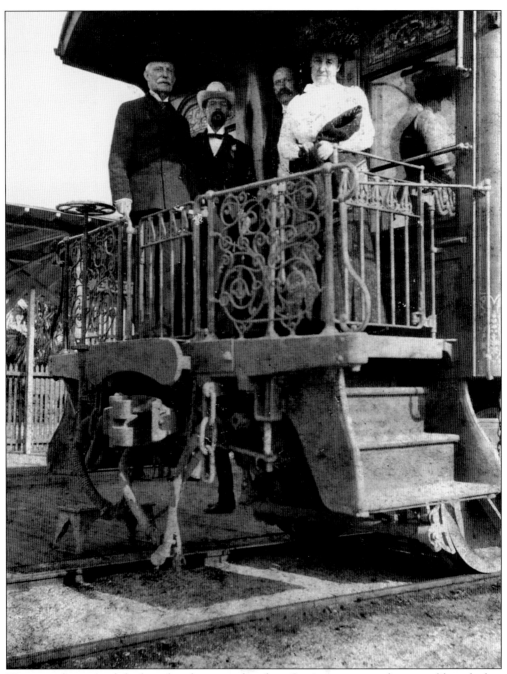

No matter how grand the boarding houses or hotels in St. Augustine, nothing would rival what the recent San Marco guest, Henry Flagler, was imagining. As the 1800s drew to a close, Flagler grabbed the mythical golden ring inscribed, "develop that old town." His image of what St. Augustine could become—the "Newport of the South"—was to be his next great ambition. Seen above, Henry Flagler, far left, and his third wife, Mary Lily Kenan, arrive in St. Augustine for their seasonal visit.

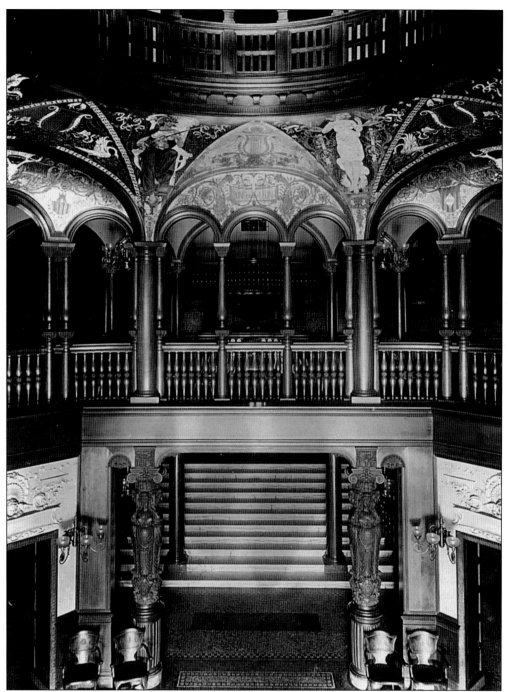

In 1886, Henry Flagler commissioned Carrere and Hastings to design one of the world's most gracious hotels, the Ponce de Leon. He spared no expense in its construction or in the quality of its interior and furnishings. When complete, the Ponce cost $2.5 million, half of what the United States paid for Florida. The stairs leading to the second floor-dining hall were crafted of onyx and its stained glass windows designed by New York's Louis Comfort Tiffany. Seating capacity for the Ponce dining hall comfortably accommodated 800.

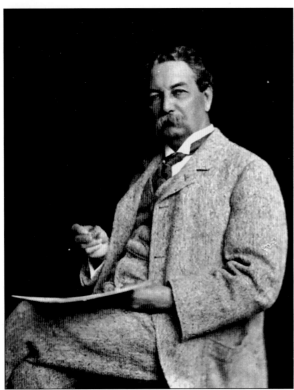

Andrew Anderson II was instrumental in assisting Henry Flagler with purchasing property in St. Augustine. He even sold Flagler some of his property adjacent to the Ponce. Anderson was a prominent physician and served as the city's mayor from 1886 to 1887. He gave St. Augustine the marble lions at the foot of the bridge that spans the Matanzas, later named the Bridge of Lions. Anderson also donated the statue of Ponce de Leon located east of the Plaza.

In 1899, *The Tatler* described a gathering of guests at the Ponce: "This superb hotel was the scene of unusual splendor . . . when the four hundred guests, right regally arrayed, gathered" for dining, card playing, and conversation.

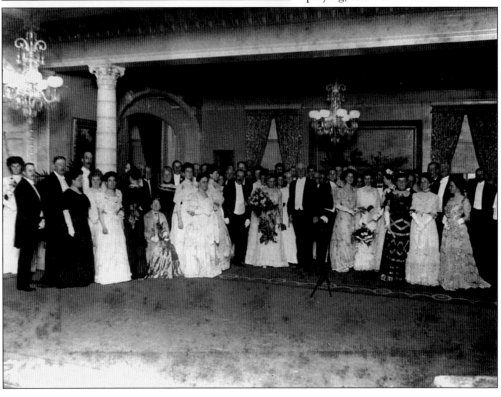

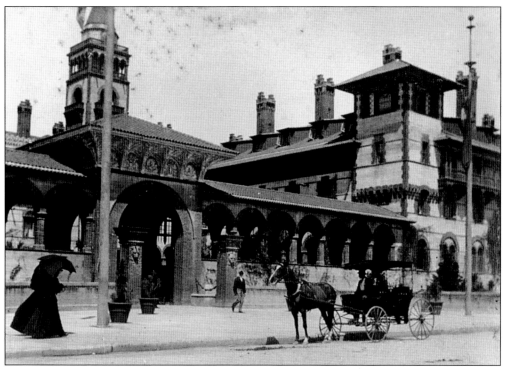

The Hotel Ponce de Leon was equipped with all the latest inventions to make life easier for those who served and more luxurious for those who played and paid. Such notables as Henry James, Admiral Dewey, and President Teddy Roosevelt, pictured below from left to right, visited the Ponce during Henry Flagler's reign in St. Augustine.

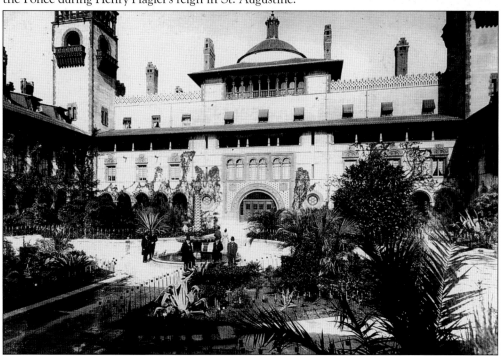

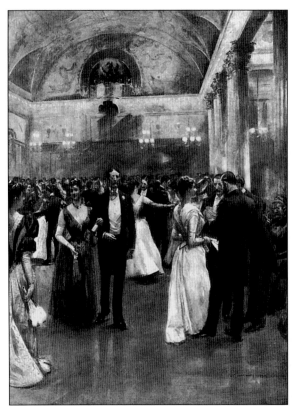

Always a favorite pastime with the hotel's wealthy clients, men and women vied for who would be the best dressed. Silk, ermine, brocade, and jewels sparkled beneath the magnificent chandeliers of the Ponce. Elegant ladies were gracefully guided along the marble inlaid floors by equally dashing black-coated gentlemen.

Foods fresh from the north or homegrown on Flagler's farm outside of town were imported on Flagler railroad cars. Everything was big and grand—from the coffee urns to the newly invented dishwasher to the vats for food storage and food preparation to the iceboxes filled with ice shipped south. Flagler spared no expense in serving the finest cuisine to his very elite clientele.

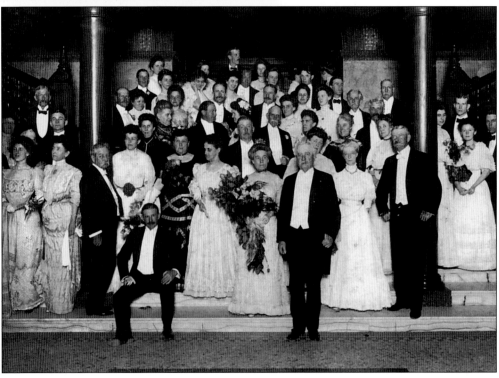

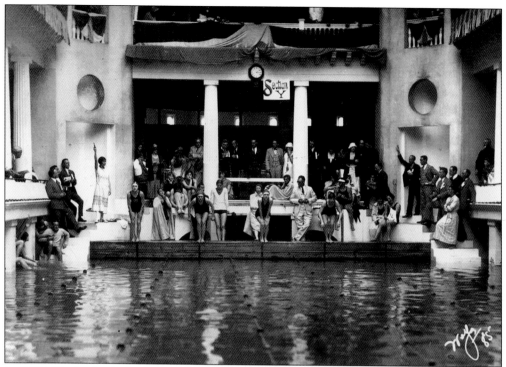

In 1887, Flagler built the Hotel Alcazar, outfitted with the world's largest indoor swimming pool. A favorite pastime for guests was to stand on the balcony and toss pennies into the pool for neighborhood boys to retrieve. This photo depicts the 1925 Women's National Amateur Athletic Union Indoor Swimming Championship.

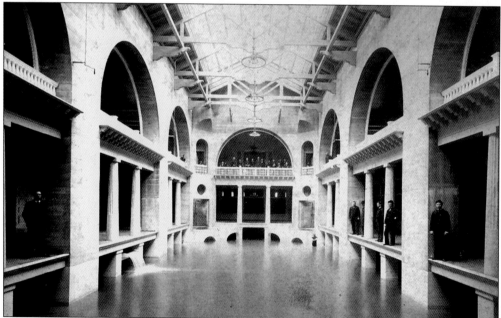

The Alcazar Casino overlooking the famous Alcazar swimming pool was a great hide-out for a hearty game of poker, a stiff drink, and an aromatic Cuban cigar.

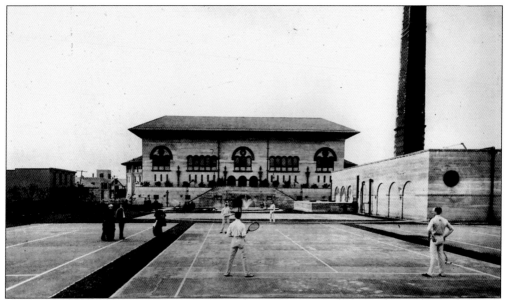

Seasonal residents played tennis on the Alcazar courts or partied around the pool.

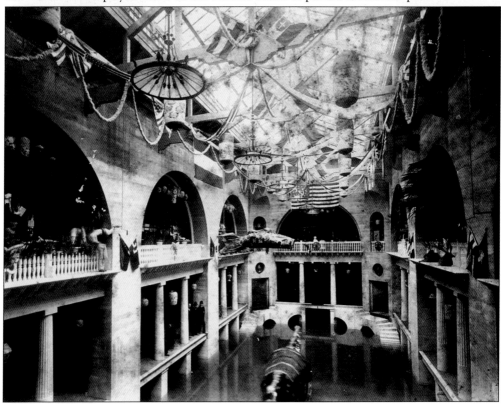

While Flagler was building the Ponce, Franklin W. Smith was constructing a hotel on the opposite corner, the Casa Monica, named for Saint Augustine's mother. Smith, who found himself short of funds during construction, sold the Casa Monica to Flagler. Flagler renamed it the Cordova.

In order to bring his guests to town in comfort and style, Flagler expanded the railway from Jacksonville south to St. Augustine. He built a railway station, filled wetlands, felled trees, constructed numerous public buildings, and paved the streets surrounding his hotels. Thus, Henry Morrison Flagler, visionary image-maker, pushed quiet St. Augustine out onto the "tourist" route forever.

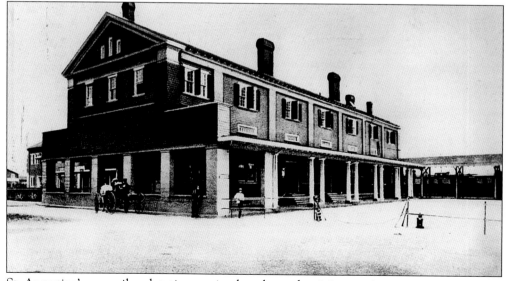

St. Augustine's new railroad station graciously welcomed arriving tourists.

Numerous entrepreneurs arrived in St. Augustine to take advantage of Flagler's project to develop Florida's East Coast as a premiere winter haven for the wealthy. One such individual was Ward Grenelle Foster who opened the city's first travel agency, The Standard Guide Information Bureau. When visitors inquired as to where they might obtain information on travel arrangements further south, where to go, or what to do while in town, the answer was always, "Ask Mr. Foster!" After meeting with numerous visitors for personal explanations of the schedules and information contained in *The Standard Guide to Florida, the East Coast, Nassau & Cuba,* distributed at his Hotel Cordova office, Foster changed the name of his business to, what else—Ask Mr. Foster!

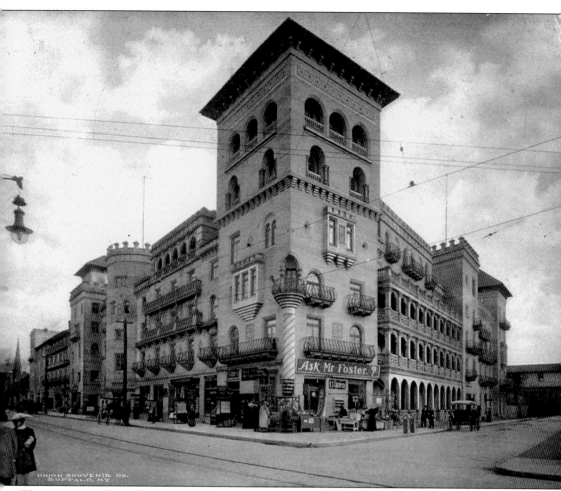

Those interested in shopping could always find something of quality in the grand hotels' fashionable ground floor shops. The Cordova was conveniently situated across the street from the Alcazar and the Ponce de Leon Hotels. Notable people, often dissatisfied with their surroundings, visited Foster's shop for advice. One of these people was Thomas Edison. As the story goes, when Edison vacationed in St. Augustine during an unusually bitter cold spell for Florida, he asked Mr. Foster where else in Florida he might find a more amenable climate. Mr. Foster remarked, "Try Fort Myers." Edison, along with his friend Henry Ford, did just that.

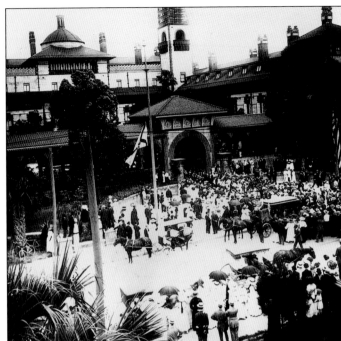

Henry Flagler's image of St. Augustine as the "Newport of the South" was never realized. By the late 1890s, he redirected his energies south to undeveloped territory—Palm Beach and Miami. Try as he might, Flagler, unable to quicken the pulse of St. Augustine's city officials, still maintained that his spirit would always rest with the old town.

On May 23, 1913, Henry Morrison Flagler, at his request, was laid to rest in the church he built in memory of his eldest daughter. He first lay in state under the grand rotunda of his Hotel Ponce de Leon before making his final journey through the streets of St. Augustine and to the Presbyterian Church. With Flagler's passing, the glimmer of gold that had haloed fair St. Augustine for many seasons now seemed somehow tarnished. High society in the old town would never quite be the same again.

Two

THE SIGHTSEER

What did "strangers" do when they wintered in St. Augustine? The same thing that most modern tourists do—wander about town, sample local cuisine, shop, visit points of interest, or sketch and paint historical sites. They would purchase stereoscopic views and mail postcards home. Since the camera was too cumbersome to carry on a trip, professional photographers were readily available. After all, how could a visitor authenticate a remarkable vacation without visual documentation?

It was providential that at the same time St. Augustine's popularity as a winter resort was gaining momentum due to Henry Flagler's driving vision, another entrepreneur, George Eastman, invented a device which allowed people to take their own photographs. By 1888, his hand-held box had literally banished the mystique of image-taking by making it practical and affordable for the public. When asked why he invented such a contraption, Eastman explained, "It seemed that one ought to be able to carry less than a packhorse load."

With this advancement in photography, amateur photographers avidly practiced their skills in old St. Augustine, the flourishing vacation spot of the South. Shops advertising photographic supplies for amateurs, even a dark room to develop one's own film, opened along the dusty streets.

Toward the late 1800s and into the early 1900s, St. Augustine welcomed a parade of professional photographers. The area's mild climate, splendid landscape, picturesque architecture, and diverse tapestry of places and faces created a perfect environment in which to add to the ever-growing image-making documentation of life in the nation's oldest city.

No matter what the subject, the style, or the type of camera used, commercial photographers, as well as amateurs, bequeathed to future generations an historical perspective that has endured for generations. Thanks to those who took photographs, we have the pleasure of viewing how strangers and tourists spent their time in the "Ancient City."

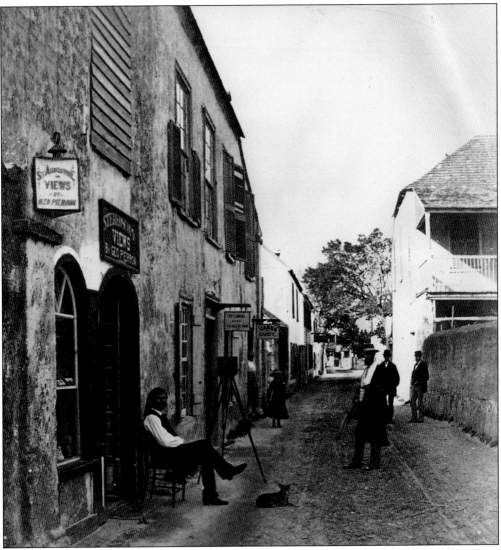

Before the days of the Eastman camera, tourists and locals could pay a professional such as George Pierron, seated, to snap their image for posterity. Photography studios became so popular in St. Augustine that they appeared on numerous dusty streets. Either the client could visit the studio or the photographer would snap a shot on site elsewhere.

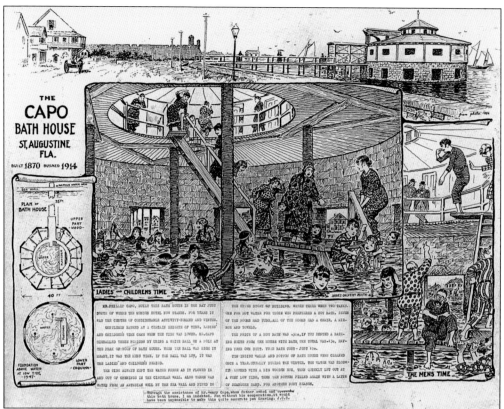

So, with camera in hand, thanks to Eastman's invention, the typical "stranger" of the 19th century and the tourist of the 20th century strolled the narrow streets of town gawking at the locals and their unique buildings. They ambled through the Plaza. They swam at designated hours in the popular Capo Bath House, fished the waters of the salty Matanzas, or perched atop the coquina sea wall to watch yacht club members race spiffy sailboats. And whatever they saw, they captured on film to take home for memories.

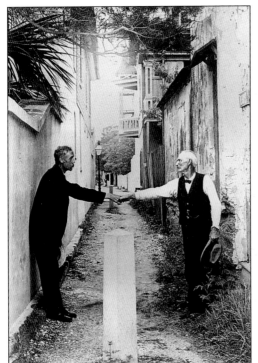
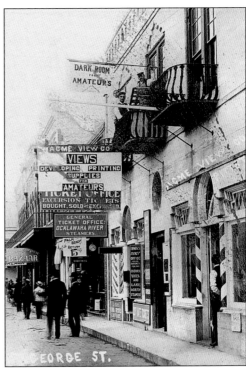

Visitors teased and posed for a handshake across Treasury Street and then walked to St. George Street to get the photograph developed.

Tourists head down King Street to the Matanzas River with fishing poles and pet.

Greenleaf & Crosby Company
Gem Merchants, Dealers in Fine Gold Jewelry, Importers of Artistic
European Merchandise and Makers of Silver Souvenirs of the Sunny South.
Shop, 17 & 19 Alcazar Court. ; : Visitors Cordially Welcome.

Shopping was a pleasure in the 1880s, the 1900s, and beyond. Early stores near the Plaza offered a wide selection of items. Handmade jewelry, hand-rolled Cuban cigars, and elegant clothing from New York and Paris were all available in Flagler's newly created vacation spot.

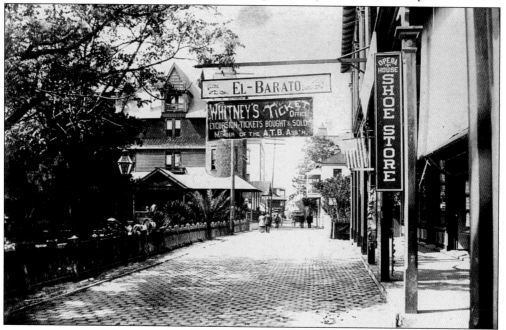

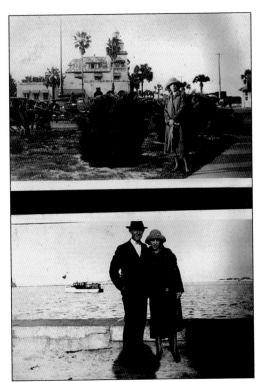

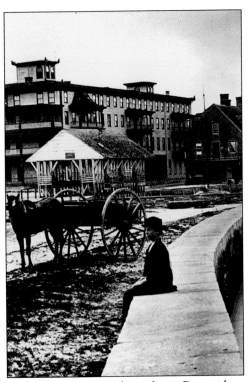

The downtown Plaza and waterfront were always pretty places to pose for a photo. Pictured on the right is the St. Augustine House Hotel, the fish market, and the Masonic Lodge. In the late 1800s and early 1900s, these buildings comprised the heart of the downtown waterfront.

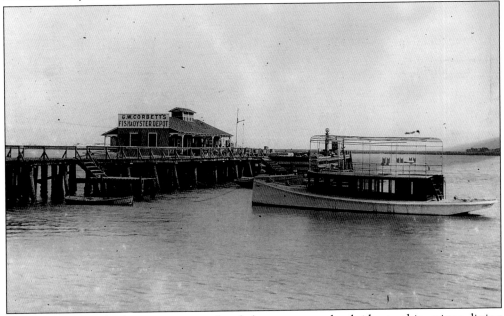

For a delicious seafood menu, strangers headed across a wooden bridge to this unique dining spot perched above the Matanzas River. Now extant, Corbett's Fish and Oyster Depot was a favorite eatery.

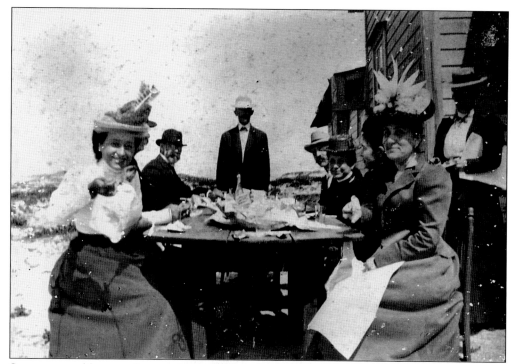

Strangers could rent a boat and ferry across the Tolomato River to North Beach to devour oysters roasted by the Minorcan families—the Usinas and the Capos. For an additional 25¢, they could gorge on delectable chicken pilau, fresh clam chowder, corndodgers, and steamed corn-on-the cob.

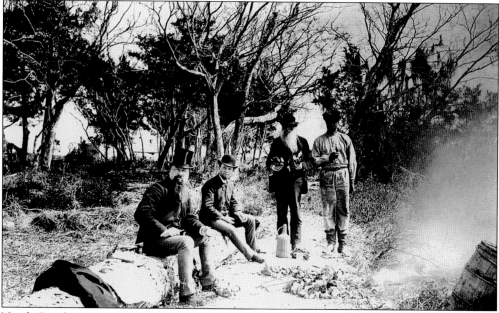

North Beach oyster roasts offered a formal atmosphere with tables and chairs but Anastasia Island's South Beach, also a popular spot for oyster roasts and picnics, offered less comfortable, more natural accommodations.

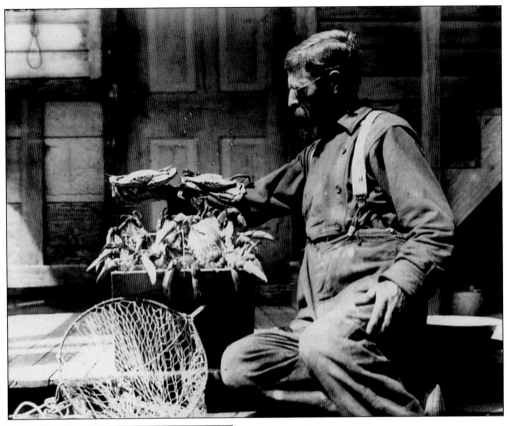

Ernest Meyer, one of St. Augustine's most prolific seasonal photographers, took matters into his own hands, quite literally, and went to Moultrie Creek to crack his own oysters and catch his own crabs. One wonders if Meyer set the camera's shutter and then ran for the porch to snap himself in action.

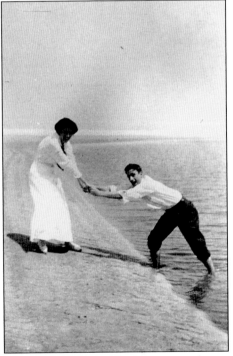

Some young folks were more interested in playing and flirting than eating. This beach scene typifies the romantic aspect of St. Augustine and its beautiful waterways.

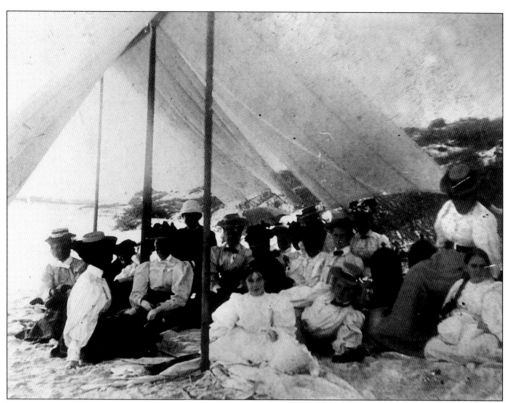

Sedate and proper women and young ladies enjoy a day on the beach before the turn of the 19th century. As always, the ubiquitous tripod camera was waiting to record their excursions.

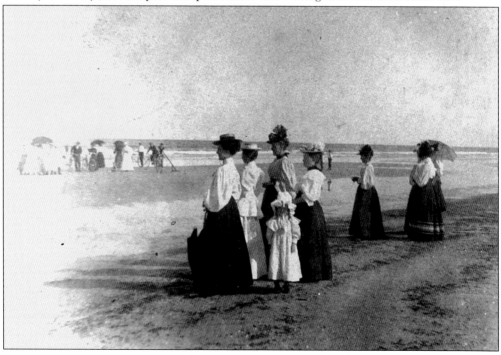

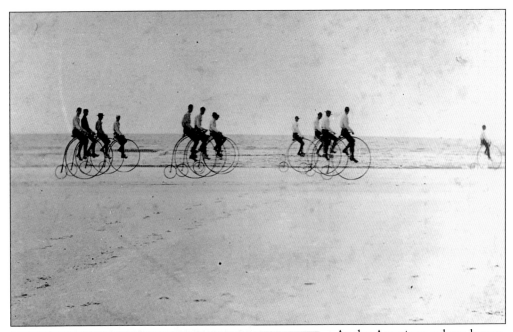

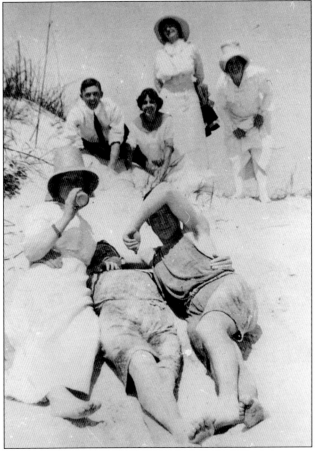

As the American culture began its shift from the staid and rigid Victorian lifestyle to the approaching bawdy and gaudy flapper era, St. Augustine's beaches filled with vigorous athletes and leisurely sun-worshippers with more relaxed behavior and dress. Young men, still somewhat formally attired, perch themselves atop their high-wheelers and entertain those who prefer to stretch out amidst the sandy dunes.

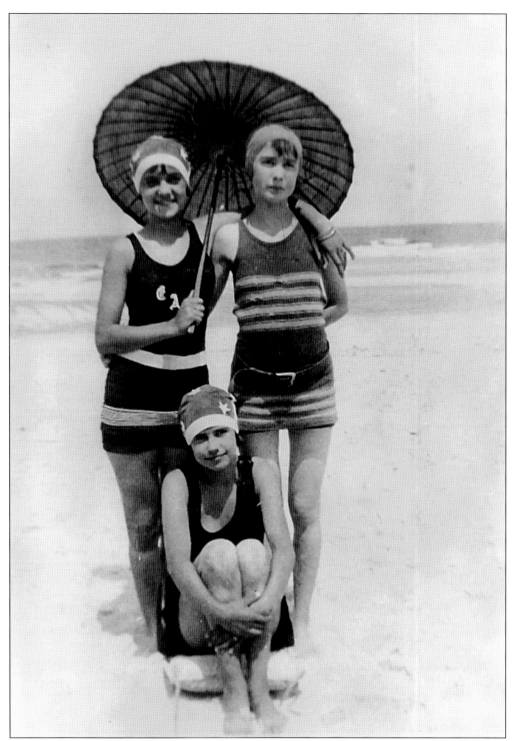

A 1925 bevy of beach bathing beauties become more daring in their dress. Still a bit of modesty prevailed with woolen swim suits, caps, and a parasol. After all, suntan lotion had yet to be created.

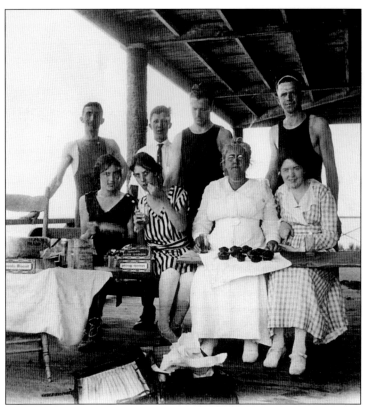

While many young folk sunned themselves, more reserved folk ate biscuits on the boardwalk. Some enjoyed freshly baked goodies to a wild clamor along the Atlantic Ocean. Others appear to have taken a break from frolicking at the water's edge to join the picnic.

There was always something "free" to do in old St. Augustine. The streets, the bay, the shops, and the beaches awaited the expectant tourist. For those who wanted a "free" concert, all they had to do was wait. Sooner or later a street musician would appear to serenade an appreciative audience and hope a bit of change would be dropped his way. The Magnolia House is pictured in the background.

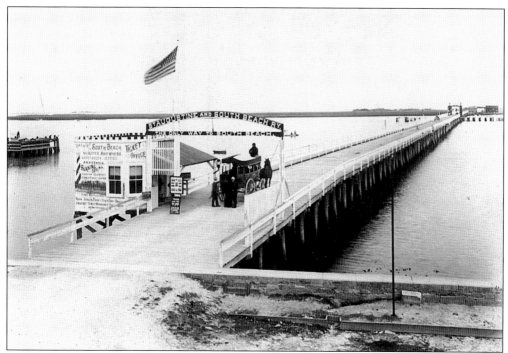

In the "good old days," St. Augustine had tourist attractions where, for a nominal fee, a visitor could learn more about the cultural and natural history of the city. When a bridge was constructed across the Matanzas River in the 1890s, a horse and buggy took strangers to the lighthouse, to Burning Springs, to the alligator farm, and to the beach.

One of the most popular stops was the alligator farm and museum that opened on Anastasia Island in 1893. Strangers would catch a ride at the foot of the Plaza to travel across the Matanzas River to view the leviathan monsters held captive behind the walls of the farm.

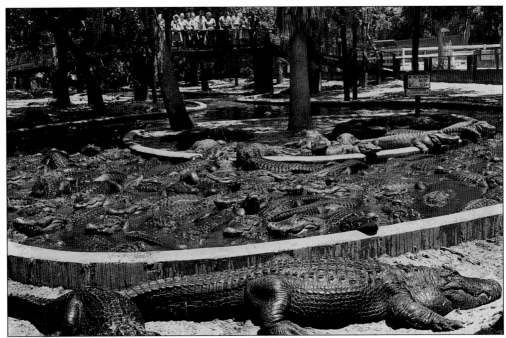

A description of fearsome gators in Florida was written in 1791 by American botanist William Bartram. In his book *The Travels of William Bartram*, he penned: "The crocodiles began to roar and appear in uncommon numbers along the shores and in the river. I fixed my camp...under the shelter of a large Live Oak.... From this...I had a free prospect of the river, which was a matter of no trivial consideration to me, having good reason to dread the subtle attacks of the allegators, who were crouding about my harbour.... [T]he river...appeared to be one solid bank of...alligators...in such incredible numbers, and so close together from shore to shore, that it would have been easy to have walked across on their heads, had the animals been harmless...."

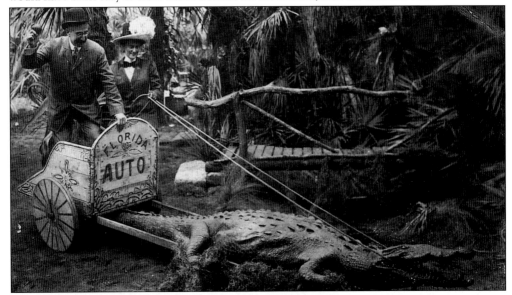

Then there was always the humorous depiction of the dreaded gator, a creature appearing in an early Florida advertisement as easily tamed and easily trained.

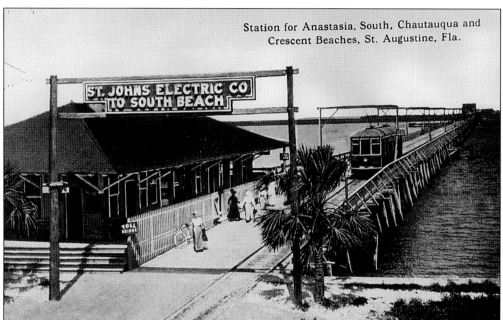

Station for Anastasia, South, Chautauqua and Crescent Beaches, St. Augustine, Fla.

Another adventure for strangers was to ride on the St. Johns Electric Company rail car across the Matanzas River to the ancient Spanish watchtower ruins, located within yards of the Atlantic Ocean.

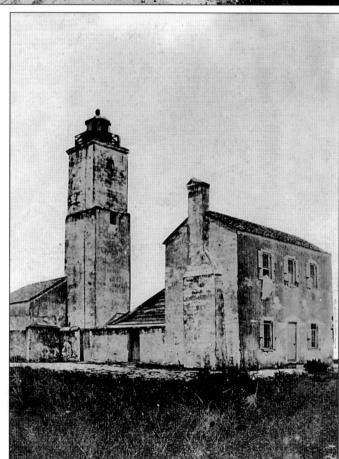

In 1823, two years after the United States gained possession of Florida, the government spent $5,000 to convert the old stone tower into a lighthouse to which they later added 52 feet. By 1871, ocean waves lapped at its base. In 1873, Congress constructed a new lighthouse. Then, in 1880, the ancient coquina tower crumbled into the sea, leaving the new swirling black and white, red-capped brick structure a lone sentinel on the horizon.

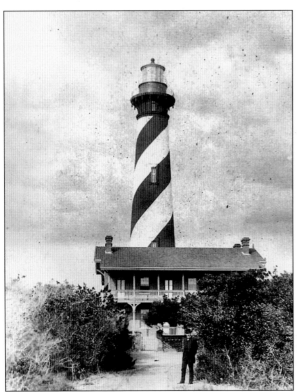

The United State Coast Guard also constructed a home for the lighthouse keepers. This building, a two-story brick duplex, housed the keeper and his family on one side and the assistant keeper and his family on the other.

After visiting the lighthouse, sightseers could continue their journey south to Assembly Beach where they found bicycles, horse and buggies, sand dunes, and pavilions to ease their boredom or titilate their adventurous nature.

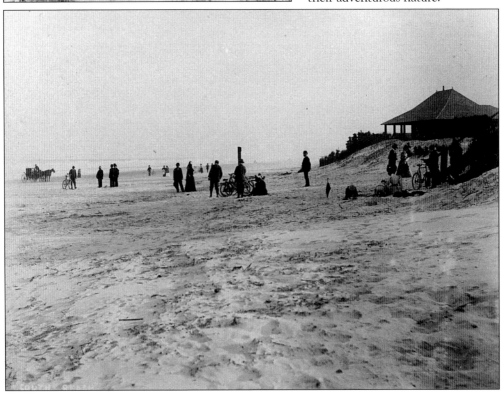

In 1892, the Oldest House was promoted as such by its owner who, of course, charged a small entry fee. In 1918, the St. Augustine Historical Society purchased the two-story coquina and frame building and adjacent grounds. According to archaeological research, its site has been continuously occupied since the mid-1600s. The building has experienced an evolution of architectural styles and adaptations since it was constructed in the early 1700s.

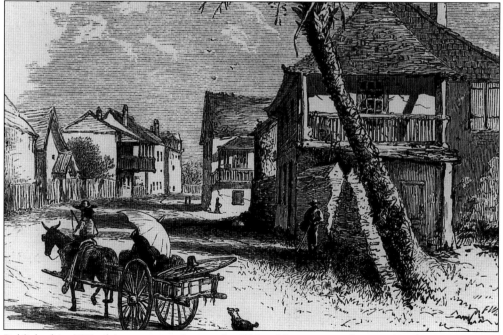

Published in 1874, this engraving depicts the Oldest House in a sad state of neglect.

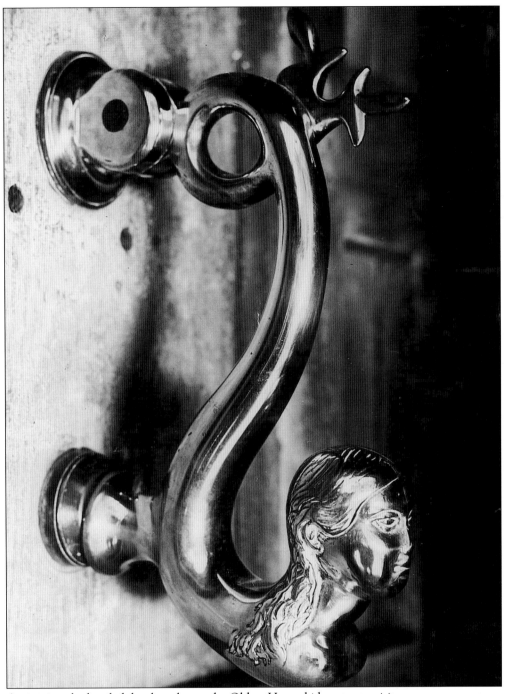

An intricately detailed doorknocker at the Oldest House bids entry to visitors.

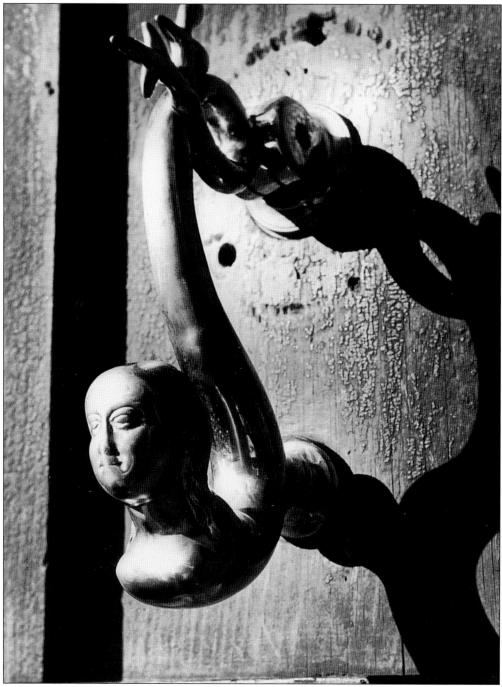

Evidently, due to the overzealous pride of its caretaker, the antique doorknocker was polished almost to oblivion.

The Oldest House gets a much-needed 1959 facelift. Early 1900 additions were removed to return the house's architecture to its original Spanish and English influence.

A rather somber group awaits the reading of the marriage vows in the Oldest House Garden, c. 1940. Winona Oliver, right, was a tour guide at the Oldest House and stood as a witness for the occasion. (The others are unidentified.) For decades, the garden of the Oldest House has been a colorful backdrop for baptisms and weddings.

The Oldest Schoolhouse, built as a residence in 1805, opened in 1939 as a tourist attraction claiming to be the "Oldest Wooden School House" in America. The building has been a popular site for decades although historical documentation is lacking as to whether the building was anything more than a home, possibly a kindergarten, a store, a café, and a museum of early school memorabilia and wax figures.

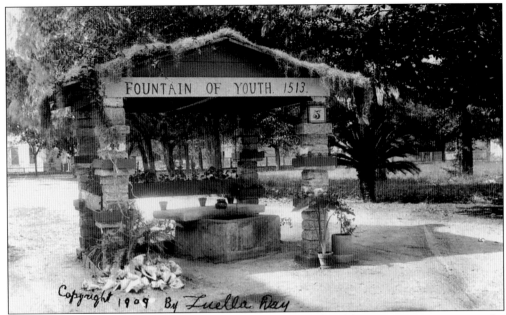

Copyright 1909 By Luella Day

Before we end our photographic journey through some of the oldest tourist attractions in the United States, we must not fail to mention the continuing legend that accompanies one of the reasons that Florida was originally explored—Juan Ponce de León's search for the Fountain of Youth. Although historical research is unable to place de León near the present-day location of this fabled life-lengthening spring, the myth gained momentum with an enterprising Yukon physician, Luella Day McConnell. In the early 1900s, she moved to St. Augustine, purchased the property, and created this delightful tourist enterprise.

There seemed to be some conflict as to exactly where the "real" Fountain of Youth was located. In 1885, one claim was that Mr. Whitney of Master's Drive owned the only authentic spring.

Young maidens serve up a cup of sparkling spring water from The Fountain of Youth. This clear beverage, with its sulfur odor and crisp pungent taste, is still offered free to all who dare to partake and those desperate to reverse the aging process.

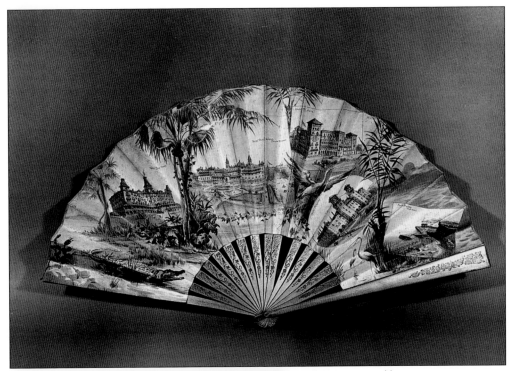

Of course, no self-respecting stranger or tourist would leave the charming ancient city without some sort of souvenir. In fact, early Florida souvenirs—lovingly called "Florida Trash"—are now considered collectors' items. These modern-day artifacts are almost as ardently acquired as the 16th century Spaniards' zealous search for gold in the New World. The silk fan displays St. Augustine's Grand Hotel System.

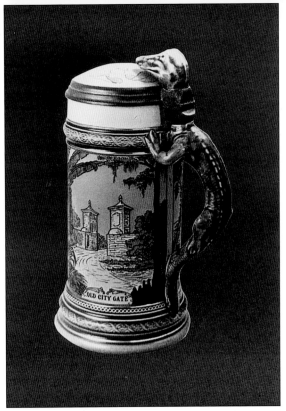

No matter where a tourist vacationed, the ever-handy and ever-practical beer stein was a must-buy memento. This glazed ceramic souvenir advertised St. Augustine's Old City Gate.

Three

THE FORT

When the Spanish decided to replace the last of their nine wooden forts with more substantial protection, the perfect building material they needed lay buried in the sand on Anastasia Island. That natural substance, never before used in La Florida, was the long-lasting, durable coquina, a soft, porous limestone made from centuries of compressed shell and coral. Due to its abundance and relative ease in mining and cutting, coquina became a valuable natural resource. In fact, San Agustín's governor declared that no other use could be made of coquina until the fort was complete.

A site was chosen for the fort on the west bank of the Matanzas River, offering a sweeping view of the Atlantic Ocean. Ground was broken on October 2, 1672, for one of the first major European constructions in the New World. In 1695, the massive Castillo de San Marcos was complete, stocked with provisions and freshwater wells. The fort now stood prepared to protect San Agustín's population from the enemy, especially its British neighbors to the north.

During ensuing attacks on the Castillo, cannonballs finding their mark against the thick coquina walls could not cause the fort to tumble. The Castillo de San Marcos was built to be used indefinitely—and to be enjoyed forever.

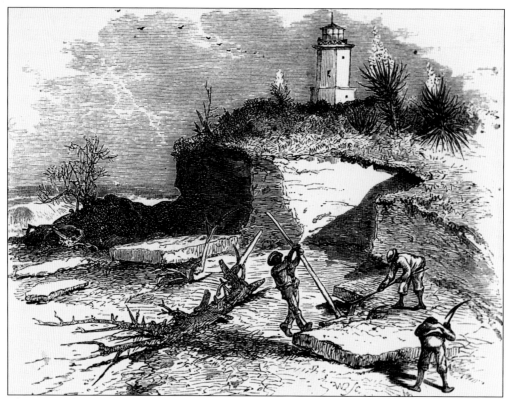

The quarried coquina rock on Anastasia Island that was used to build the Castillo de San Marcos was also used in the construction of numerous other buildings in St. Augustine, including the Spanish watchtower perched atop the sand dune, depicted in the above drawing.

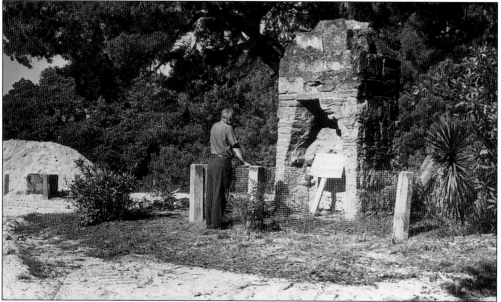

The only remaining portion of the coquina quarry on Anastasia Island is the quarry house chimney and fireplace.

50

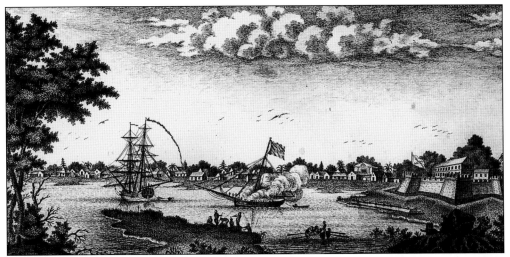

A 1742 woodcut depicts one of several failed British attempts to conquer St. Augustine. When the British finally gained possession of the town in 1763, the fort's name was changed to Castle St. Marks.

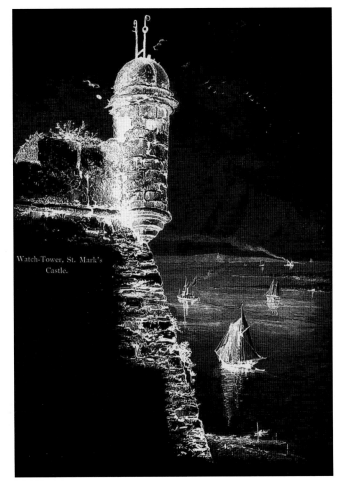

Watch-Tower, St. Mark's Castle.

The Bastion of Castle St. Marks juts prominently over the Matanzas River with the Atlantic Ocean beyond.

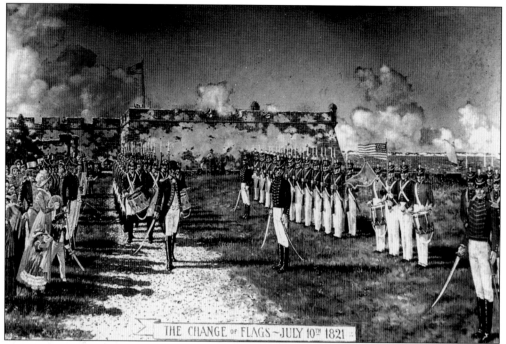

In 1825, four years after the United States took possession of Florida, the impenetrable coquina fortification received a new name, Fort Marion, in honor of the American Revolutionary War hero from South Carolina, Gen. Francis Marion.

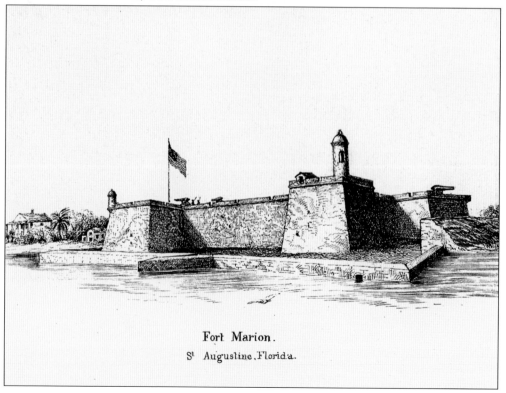

Fort Marion.
St Augustine, Florida.

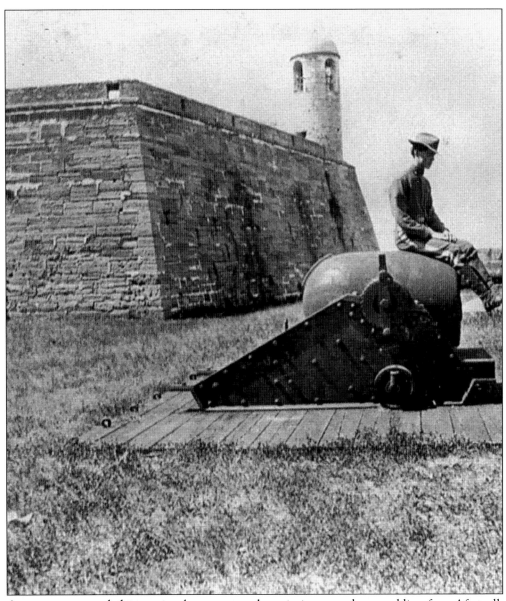

As newcomers settled in town, there was much curiosity over the crumbling fort. After all, no one had ever seen such a monstrous manmade structure or been allowed to wander freely through its damp, decaying rooms. Although no military engagement occurred at Fort Marion after it passed into the hands of the United States government, the coquina bastion was used extensively by the military throughout the Seminole Indian Wars, the Civil War, the Spanish-American War, and World Wars I and II.

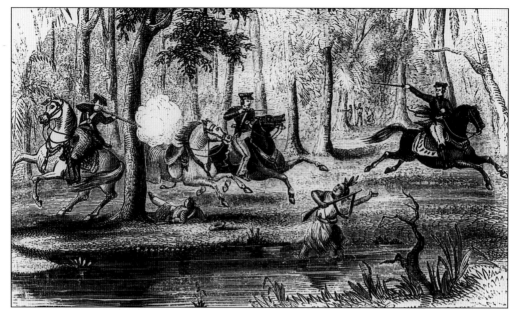

After Florida became part of the United States, a tide of white settlers flooded the peninsula, appropriating property claimed by the Seminole Indians. To ease tension, the government granted the Seminoles title to over four million acres in Central Florida. However, by 1835, Americans were demanding that land as well. At the same time, they were calling for relocation of all Seminoles to the Southwest. The Seminoles' outraged response was the Second Seminole Indian War.

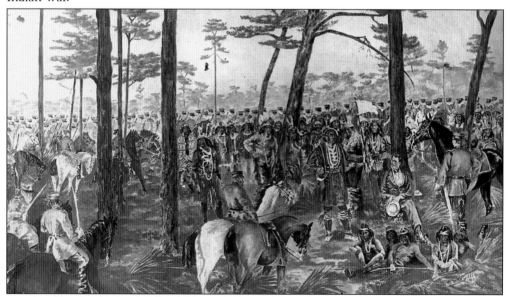

Osceola, a popular Seminole warrior with a charismatic personality and ruthless daring, won the hearts of his adopted tribe while his cunning bravery wrecked havoc on the U.S. Army in Florida. In October of 1837, under a white flag of truce, Osceola, accompanied by Seminole chieftains and over 80 supporters, met south of St. Augustine at Moultrie Creek to negotiate a treaty. Disregarding the universal sign of peace, U.S. Maj. Gen. Thomas Jesup ordered their capture. The Seminoles were then marched into town and imprisoned at Fort Marion.

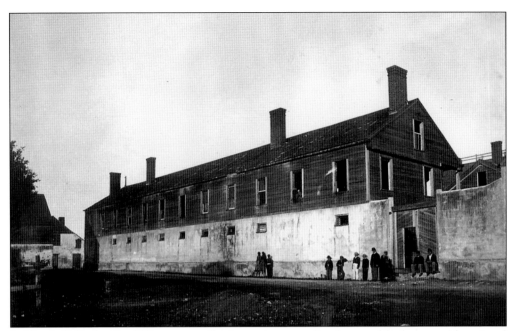

In March 1862, the Civil War came to St. Augustine, or as Southerners liked to say with regional pride, "The War of Northern Aggression has descended upon us."

Federal troops stock up on provisions at the government commissary near the Plaza.

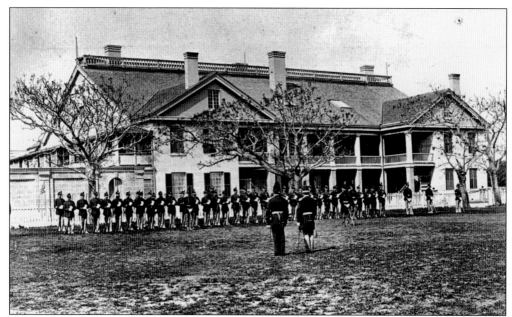

The United States Army stands at attention in front of the St. Francis Barracks south of Fort Marion *c.* 1875.

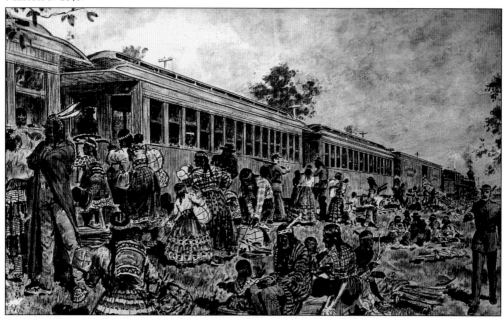

In the late 1800s, the plight of America's indigenous peoples reached a critical stage in the country's evolution. Greedy Americans grabbed fertile land west of the Mississippi River, shoving Native Americans onto some of the most arid, unproductive acreage on the continent. In 1875, Native Americans fought against the inevitable. The United States retaliated and once again, another group of Indians trudged toward Fort Marion. St. Augustine's inhabitants gathered to catch a glimpse of these new arrivals from the western frontier. With legs shackled, 70 Arapaho, Kiowa, Comanche, and Caddo tribesmen and women, branded as rebels, headed to their new "home" beside the Matanzas River.

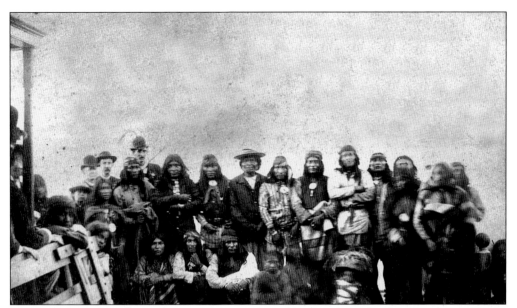

From April 1886 to November 1887, more than 500 Apaches, the last Southwest Native American tribe to be conquered, arrived in St. Augustine. Among them were two wives of the fearless Apache leader, Geronimo.

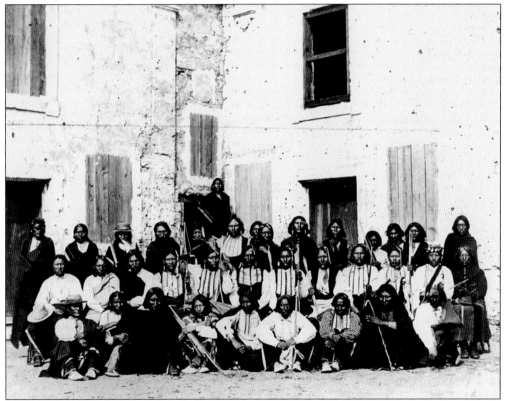

Indian prisoners pose for their photograph inside Fort Marion. Their faces are windows to their dispirited souls.

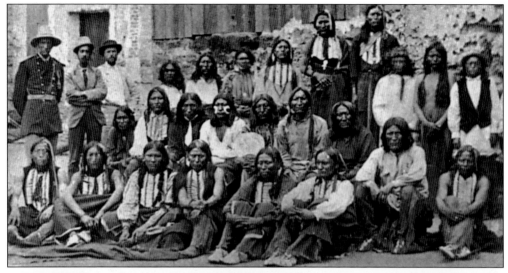

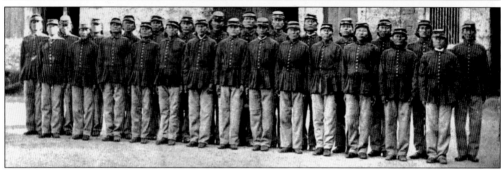

In the top photo, Native Americans pose inside their prison in everyday garb. However, they were often ordered to wear their government issue, US regulation outfits, shown in the bottom photograph.

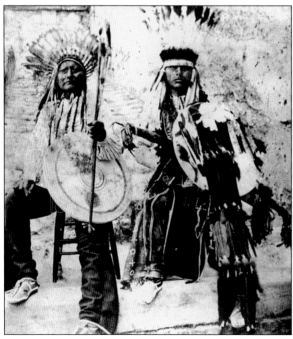

At times, Native American prisoners were allowed to dress in their native attire, informally as well as fiercely formal.

Native American prisoners artistically documented their stay at the old fort by recording with drawing supplies their experiences and observations. Primitive, yet sophisticated in detail, their artwork depicts life within the confines of the nation's oldest stone fort. Their drawings also depict their memories of the past when they were free to hunt the wide barren western plains. It is believed that these drawings were created by Apache prisoners, rather than by members of other tribes imprisoned in the fort.

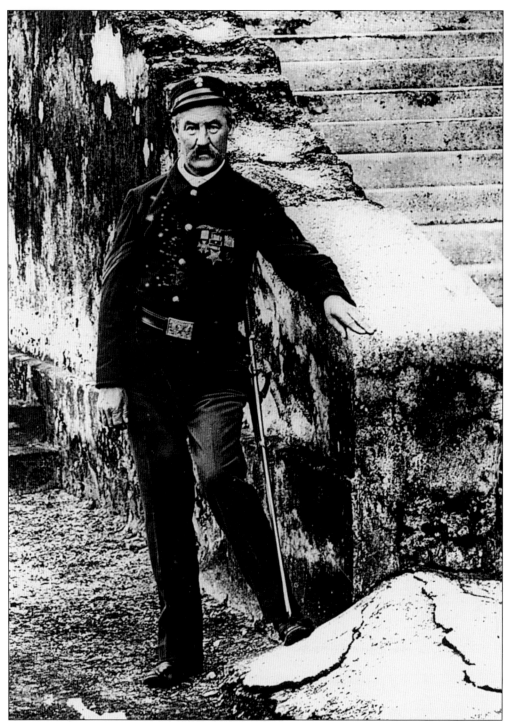

When these noble men, women, and children departed Fort Marion for the West and a new home, St. Augustinians gathered along the seawall to bid them farewell. Sgt. George Brown, stationed at Fort Marion, later reported: "During the thirteen months that I had the immediate care of these Indians, I found most of them trustworthy, truthful and honest in every respect."

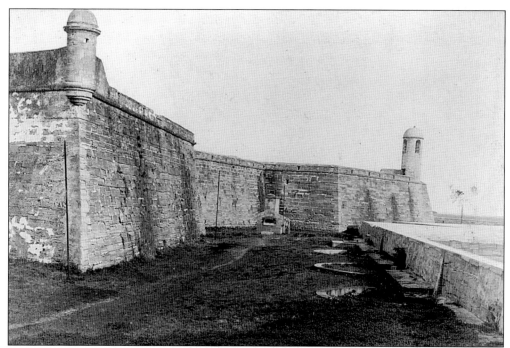

After its use as a prison for America's indigenous rebels, Fort Marion became a favorite spot to roam for both tourists and locals. Professional photographer E.A. Meyer particularly enjoyed the captivating sight of the ancient relic and recorded numerous images of the fort.

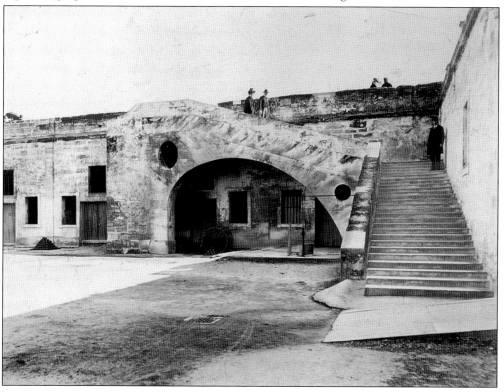

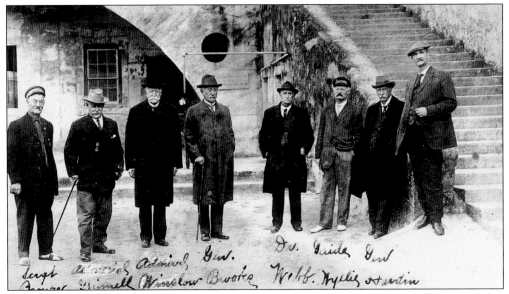

Stern dignitaries in topcoats came to inspect the crumbling fortress. Pictured above, from left to right, are Sergeant Brown, A. Grinnell, Admiral Winslow, General Brooke, Doctor Webb, Wyllie (the guide), General Hardin, and an unidentified man.

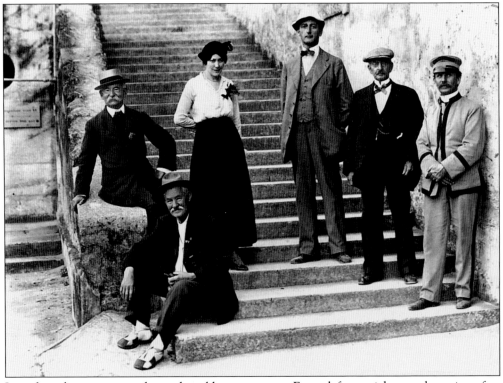

Less formal visitors posed on the old worn ramp. From left to right are long-time fort custodian George M. Brown (seated on steps), an unidentified man behind him, Mr. and Mrs. W.J. Harris, an unidentified man, and a uniformed guide whose hat bears the inscription "Historical Society."

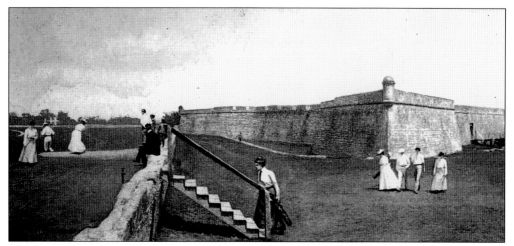

The fort green was used for a game of golf from the 1890s to the 1920s.

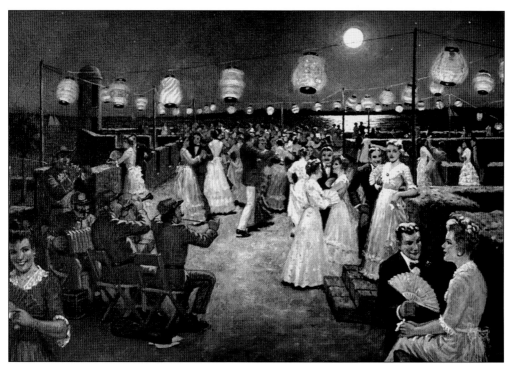

The ramparts of the fortress were used for dances.

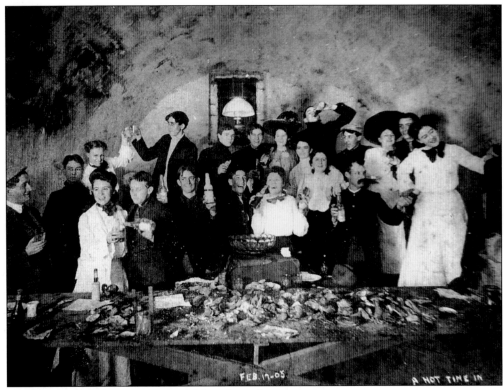

And the dank, dark rooms were used for a beer-slugging oyster roast.

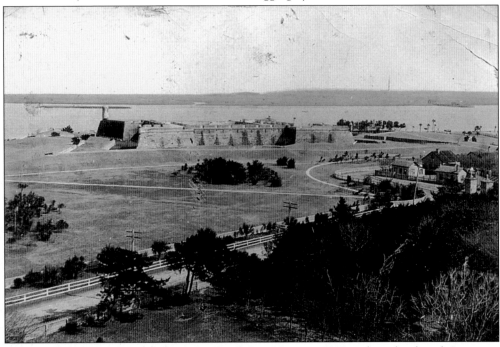

This is a view of Fort Marion from the Hotel San Marco c. 1890 with undeveloped Anastasia Island and the Atlantic Ocean in the background.

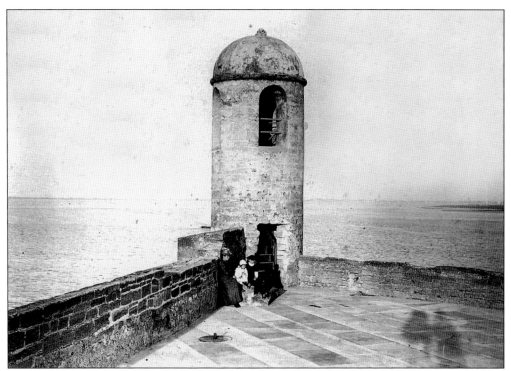

Tourists investigate Fort Marion's bastion.

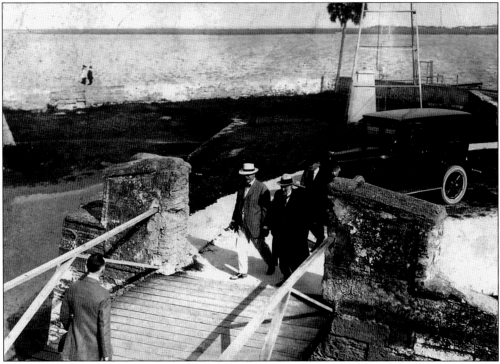

Sen. Chauncey Depew, in overcoat, conveniently drives right up to the fort's bridge across the moat to take a grand tour.

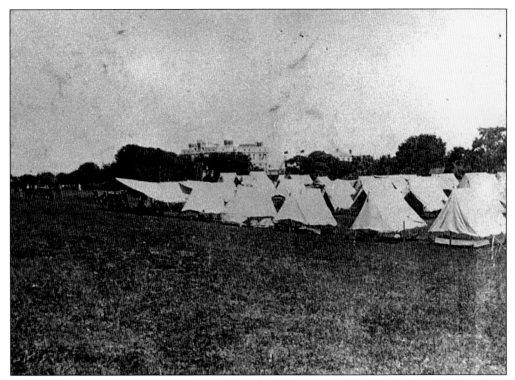

Training in 1898 for the Spanish American War took place on the fort grounds. Pup tents were set up on the expansive north lawn. In the background is Castle Warden, the building that would one day be the home of Ripley's *Believe It Or Not!*

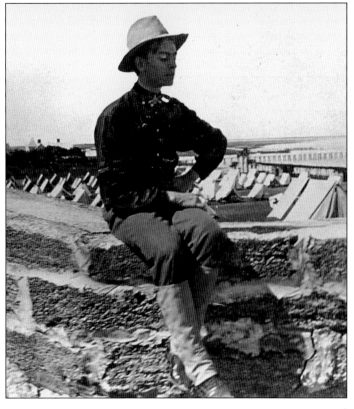

A lone warrior-in-waiting sits atop the fort's wall, possibly contemplating his fate.

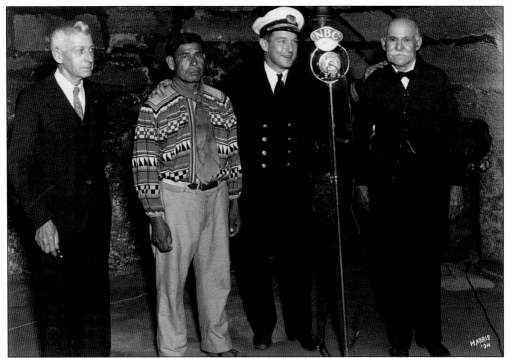

In 1924, Fort Marion was proclaimed a national monument. In 1933, the complex was transferred from the United States War Department to the new National Park Service. In March 1934, this memorable photograph was taken deep within the recesses of Fort Marion. Pictured, from left to right, are H.A. Hernandez, whose grandfather captured Osceola; Chief John Osceola, grandson of Osceola; Capt. Philip Lord; and Victoriano Capo, whose father claimed to have found the secret dungeon in the fort.

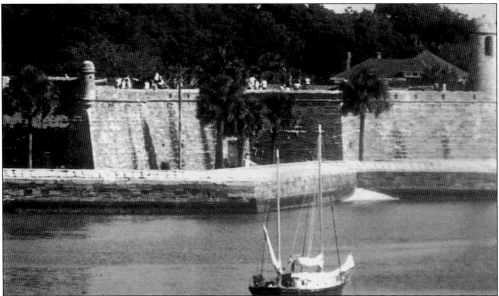

Two years later, the National Park Service began operating Fort Marion as a museum. In 1942, its original name, the Castillo de San Marcos, was reinstated.

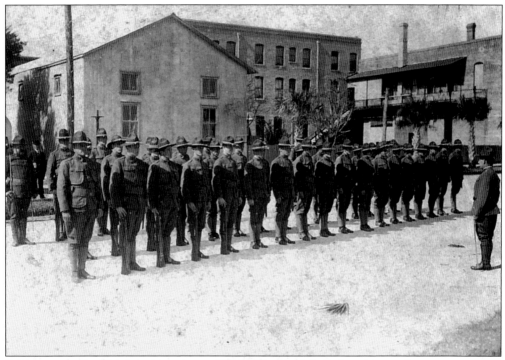

Soldiers trained in St. Augustine during World War I and drilled in the town's streets.

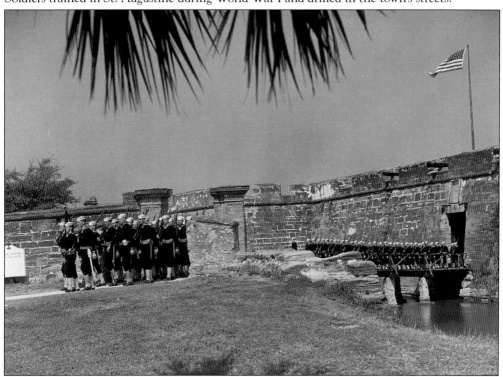

The Castillo de San Marcos again saw action during World War II as Coast Guardsmen marched through its portals.

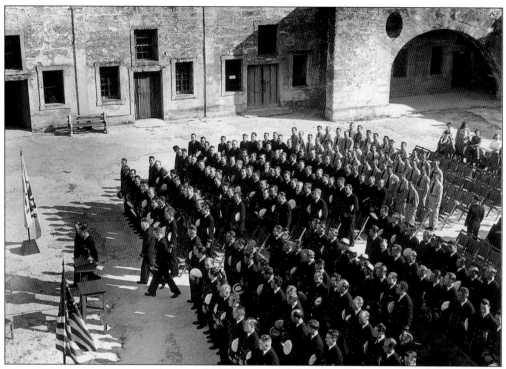

Coast Guard officers, prepared to serve their country, were commissioned in the fort's courtyard.

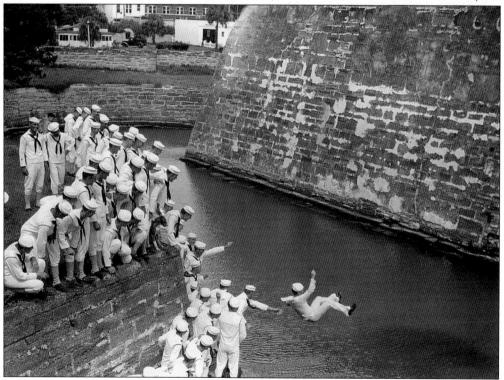

Enlisted men exuberantly celebrated their graduation by taking a swim in the fort's moat.

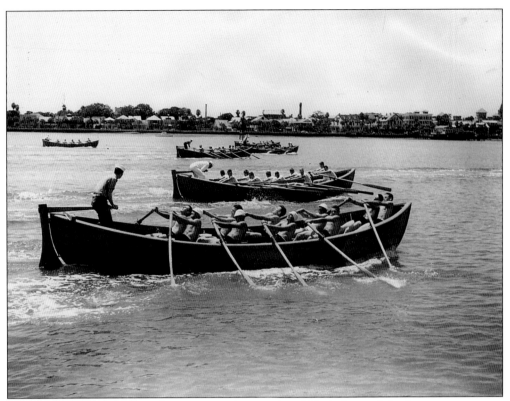

Some U.S. Coast Guard members practice their rowing skills in front of the fort.

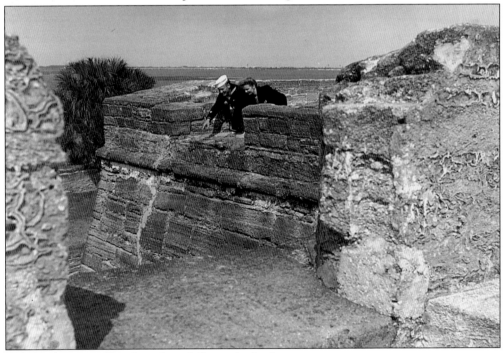

Others take time off to show their skills inside the fort.

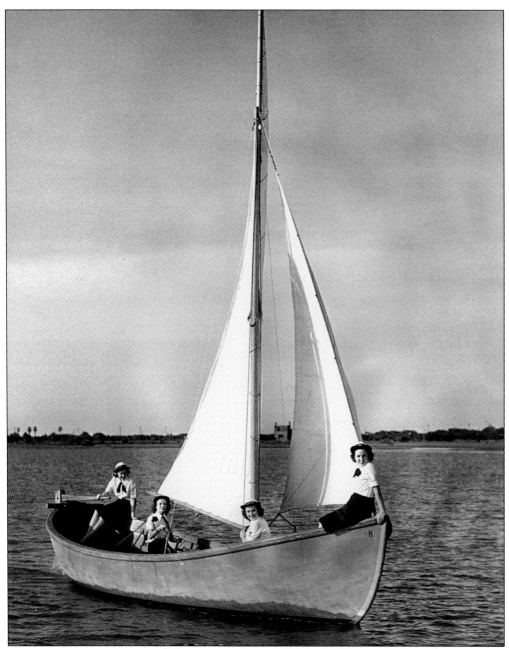

Sailing on the Matanzas River in front of the fort was a favorite pastime for relaxing military personnel. The Coast Guard Women's Reserve (SPARS), from the training station in the city, enjoyed a day on the water. From left to right are Marian Stenger, Ohio; Elizabeth Taylor, Illinois; Mary Monaghan, Iowa; and Mary Walter, Mississippi.

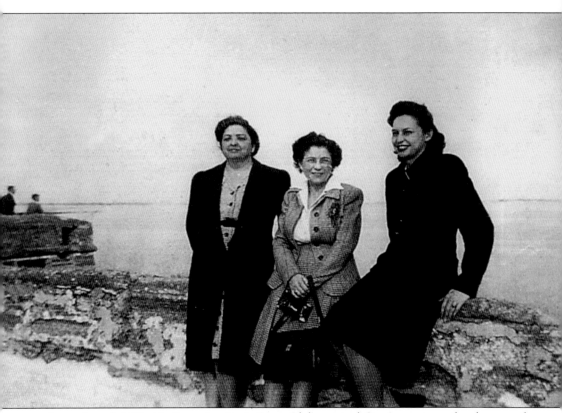

At war's end, U.S. Air Force Lt. Jessie Irene Blake visited St. Augustine—for the very first time. Having been stationed in England during the Blitzkreg, she sought refuge and renewal in Florida. Blake (right) was accompanied on her sightseeing adventure by Nocia Inman and Irma Kennedy of Jacksonville. Blake had given birth to a daughter several weeks earlier, had placed her up for adoption, and was preparing to depart for her home in Dallas. Thirty-five years later, Blake's daughter was given this photograph of her mother perched atop the rampart of the Castillo de San Marcos. With the gift of this photograph, Lt. Jessie Blake's daughter was able to gaze at an image of her natural mother—for the very first time.

Four

THE FILM INDUSTRY

Although image-making took an animated turn in 1887 from still life to moving pictures, it was not until the mid-1910s that the motion picture industry discovered the unique attributes of St. Augustine. Northeast Florida's mild winter climate, wild terrain, semi-tropical foliage, oceans, rivers, and great neighborhoods enticed filmmakers from New York, Philadelphia, and Chicago. Florida also offered less expensive labor, accommodations, and electricity than the North.

The 5¢ movie theater, or nickelodeon, was a popular form of entertainment from 1905 to 1909. However, movie theater owners, wanting to generate greater profits, took direct aim at the more affluent moviegoer by creating a demand for longer and more spectacular films. The challenge to enhance the film industry was met by the Pathé brothers from France. Their invention, a hand-cranked projector, or Cinematograph, revolutionized filmmaking and blazed a trail for what would eventually become the most profitable mass entertainment industry in the United States.

By the mid-1910s, Jacksonville, 40 miles north of St. Augustine, had become the nation's winter capital for the motion-picture industry. With each film company that came to Northeast Florida, representatives were sent to scout neighboring locales for possible film sites. St. Augustine's antiquated buildings and picturesque streets and gardens were considered a fantastic backdrop for motion pictures. Famous silent screen stars Ethel and Lionel Barrymore, Rudolph Valentino, and a few less notables such as Mary Garden, Theda Bara, and Pearl Fay White were filmed on location in St. Augustine.

Between 1912 and 1914, more motion-picture production crews worked in Northeast Florida than in Los Angeles. In May 1914, Jacksonville's *Florida Times Union* reported: "Florida, to many a few years ago, was a veritable forest of mystery, full of every imaginable beast, pitfall, swamp and tangled thicket. . . . Those who had not come and seen for themselves shied at the very mention of the name of the fair peninsula. So well can the first expeditionary forces of the motion picture artists be remembered. They came hurriedly for the color of the wild, and went away convinced that the state . . . offered a far wider range of advantages to photo-playing than any other section of America. The result has been that Florida scenes are now figuring more largely and more prominently in photo-playing than any other known section. . . ."

The *Perils of Pauline* was a 20-episode silent film serial emphasizing danger and suspense and always ending with a cliff-hanger aimed at bringing the audience back for the next episode. Pauline encountered pirates, Indians, rats, and sharks in her dramatic adventures, but her greatest villain was always her dastardly guardian. Her most familiar plight involved being tied to railroad tracks with the distant image of an approaching train. *The Perils of Pauline* proved such a great success that Pearl White was propelled into international stardom. Many of Pauline's escapades were shot *c.* 1914 at St. Augustine's new tourist attraction, the Fountain of Youth Park.

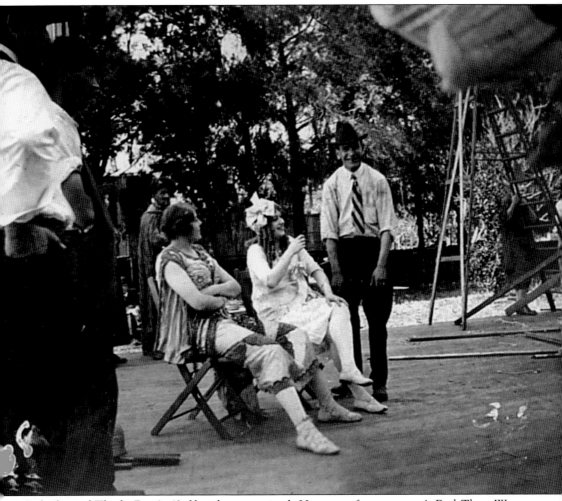

Only four of Theda Bara's 42 films have survived. Her most famous was *A Fool There Was*, adapted from Rudyard Kipling's poem, *The Vampire*, and filmed in St. Augustine *c.* 1915. Bara played the role of a vamp so compellingly that she was denounced from church pulpits across the country.

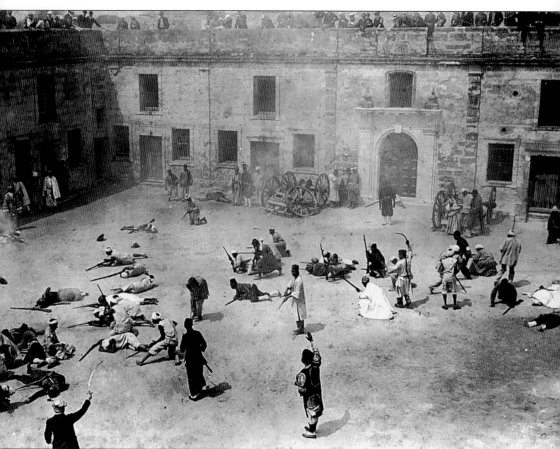

This *c.* 1915 photo of a silent film set in the Middle East was shot on location at the ancient Spanish fort. After a 1917 visit to St. Augustine, William Dean Howells published an article in *Harper's Magazine* describing the atmosphere in town during its filmmaking heyday. "St. Augustine is indeed the setting . . . [for] companies of movie players rehearsing their pantomimes everywhere. . . . No week passed without encountering these genial fellow creatures dismounting from motors . . . or delaying in them to darken an eye or redden lip or cheek or pull a bodice into shape before alighting to take part in the drama." Howells wrote, "I talk as if there were no men in these affairs but there were plenty . . . villains like brigands or smugglers or savages, with consoling cowboys or American cavalrymen for the rescue of ladies in extremity. Seeing the films so much in formation we naturally went a great deal to see them ultimated in the movie theaters, where we found them nearly all bad."

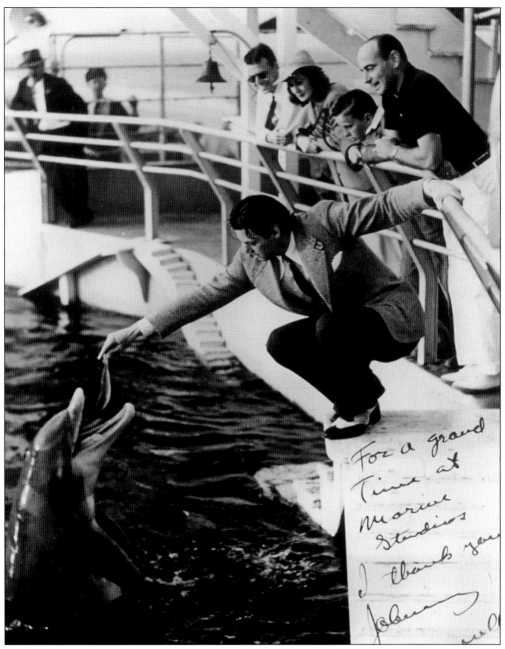

For a grand
Time at
Marine
Studios
I thank you

During WWI, interest in filmmaking in Northeast Florida waned. Financial institutions cut back on lending and producers complained that merchants would not extend credit when production costs soared. Dissatisfied and disgruntled, filmmakers collapsed their tripod cameras, gathered up their celluloid reels, and caught a slow train to Hollywood. In 1937, a few miles south of St. Augustine, Marine Studios was built by Cornelius Vanderbilt Whitney with the intention of using the tanks for underwater filmmaking in order to entice the movie industry back to Florida. In the late 1930s and 1940s, Tarzan films starring Johnny Weismuller were shot on location south of St. Augustine. Behind Weismuller, who is feeding a fish to one of the locals, is Ilia Tolstoy, manager of Marine Studios.

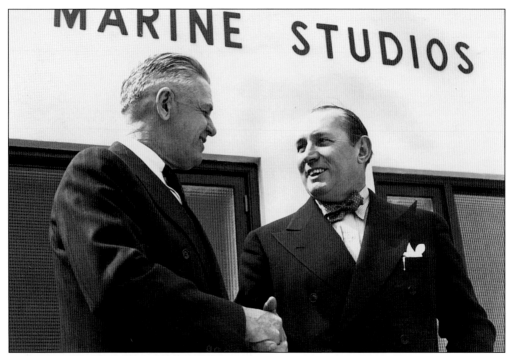

Although a few documentaries were filmed in St. Augustine during the 1930s, it was not until the completion of Marine Studios south of town that movie stars returned to the area. Walter B. Fraser, one of St. Augustine's early tourism promoters (left) shakes hands with another tourist attraction creator, Robert Ripley. Ripley's first museum, built in St. Augustine, was Ripley's *Believe It Or Not!*

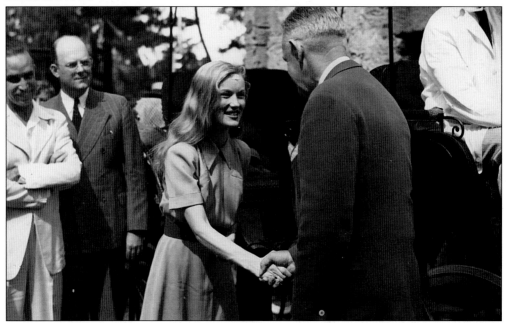

During World War II, sexy starlet Veronica Lake, a Miami native, brightened the lives of St. Augustinians by arriving to promote the sale of war bonds.

In 1951, the film industry revisited St. Augustine with one of Hollywood's most popular male stars, Gary Cooper. Cooper played a 19th-century army scout searching the Everglades for a marauding band of Seminoles threatening settlers in south Florida. *Distant Drums*, a Warner Brothers production, also starred Mari Aldon as Cooper's leading lady.

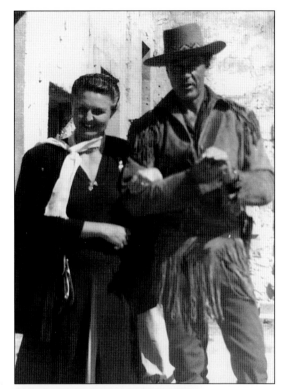

At the time of its premier on December 21, 1951, Cooper was ill in New York. Seen here bantering about at the Oldest House with Aldon, is the second male lead, Richard Webb.

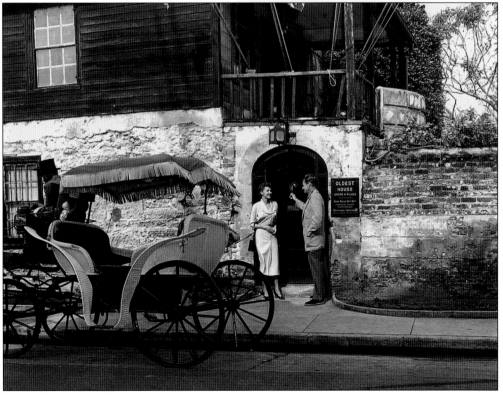

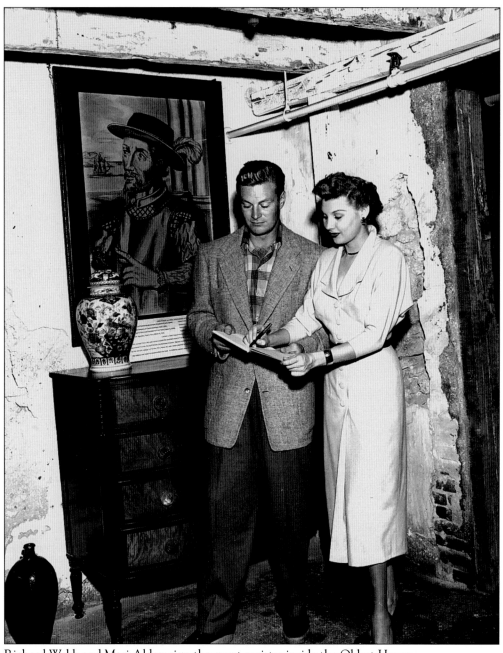

Richard Webb and Mari Aldon sign the guest register inside the Oldest House.

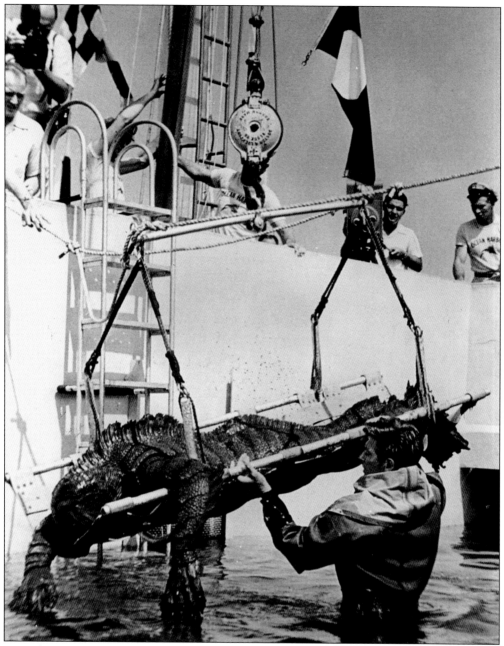

Several of the famous "creature" movies were filmed in St. Augustine and the nearby Marine Studios (now Marineland), including *Revenge of the Creature* in 1955.

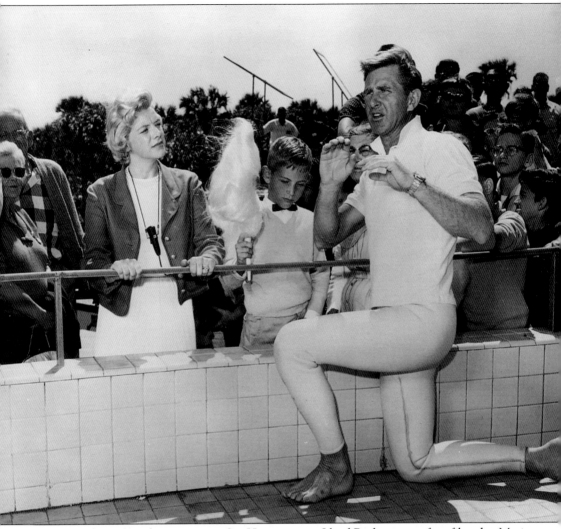

The popular 1950s television series, *Sea Hunt*, starring Lloyd Bridges, was often filmed at Marine Studios. Seen above are Rosemary Clooney and Lloyd Bridges in production for an NBC color television special. Don Germain, a local youngster who was in the film, is holding cotton candy. Buster Crabbe, not shown, also starred in the underwater spectacle sponsored by Minute Maid Orange Juice Company and Tupperware Home Parties, Inc.

Five

THE PERMANENT RESIDENT

St. Augustine, Florida, is more than a tourist destination or a backdrop for filmmaking. It is a mosaic of its people, how they live, how they work, how they play, and how they worship. It is St. Augustinians and their activities that bring life to their town and their town to life. Permanent residents protect their town's culture, customs, and civility. They provide the work force that guarantees their survival as well as the survival of their town.

Images of past residents stare back at us from the annals of time—a parade of ghosts who contributed to St. Augustine's future by dwelling in its past and who often gave their lives for their city's well-being. Crumbling headstones in aged cemeteries identify many, while others lie buried in unmarked graves now paved over for parking lots. This bygone procession represents a rich pageantry of lives: Native Americans, Europeans, and Africans.

Many left a notable mark on St. Augustine's history. They built forts and chapels, schools and hospitals, homes and farms, planting their roots deep into the sandy soil. They stayed through adversity and pleasure and rolled up their sleeves to toil in tropical humidity. They used their skills and their intelligence to mold from the shifting sand and raging sun the city we have today.

Some gave their sweat and some gave their fortune. Of the thousands who contributed to St. Augustine's development, most had no images recorded. Of many who did, theirs have been lost to time. Those images that have survived, considerately passed down from generation to generation in order to insure that they would be remembered, give us a profound reminder that it is indeed the human element that gives a town its glory.

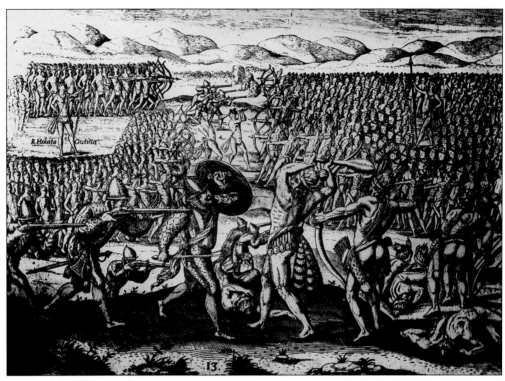

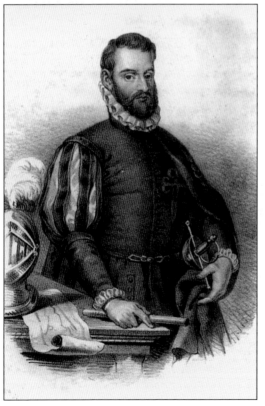

The Timucua Indians numbered in the thousands when the Spanish arrived in St. Augustine in 1565. Within 200 years, decimated by disease, slavery, and war, there remained but a handful of this aboriginal tribe.

Pedro Menéndez de Avilés founded San Agustín September 8, 1565. He died in Spain in 1574 and was buried in Avilés.

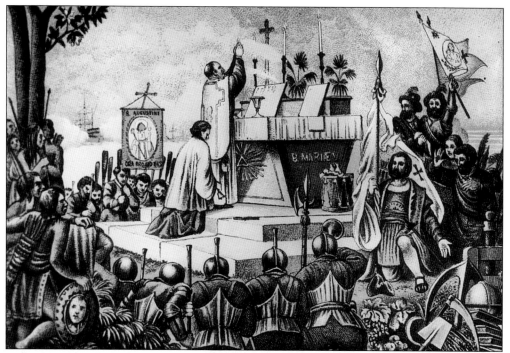

Father Francisco López de Mendoza Grajales, the Spanish priest who accompanied Menéndez on his voyage to the New World as the fleet chaplain, celebrated the first Mass in San Agustín.

Spanish settlers tilled the soil, guarded the military outpost, and, for over two centuries, held firm their possession of La Florida.

Col. James Grant, the first governor of British East Florida, held office from 1764 to 1773. During his leadership, St. Augustine prospered. Carolina planters and their African slaves relocated to Florida, bringing their farming expertise to insure success. Increased agricultural production allowed vast quantities of indigo and oranges to be exported to northern colonies as well as Europe.

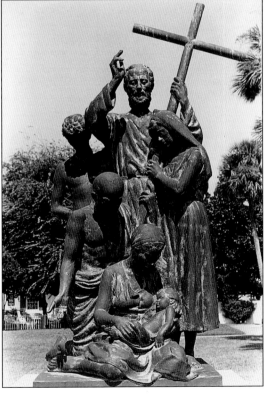

In 1768, Dr. Andrew Turnbull, a Scottish physician, promised land and freedom to hundreds of indentured servants—Minorcans, Italians, Greeks—if they would travel with him to Britain's new colony, Florida. This adventure turned rough: the soil was unproductive, and disease, mosquitoes, and misery prevailed. After losing almost 1,000 men, women, and children, in 1777, the remaining disillusioned group of 400 fled Turnbull's failed New Smyrna Colony to St. Augustine. Led north by their devoted Catholic Priest, Father Pedro Camps, they meshed into the culture as a contributing entity. Many of their descendants still live in St. Augustine.

Mary Peavett Hudson, owner of the Oldest House from 1775 to 1790, was the town's foremost midwife. The book *Maria*, by Eugenia Price, is a historical novel featuring Mary as its heroine.

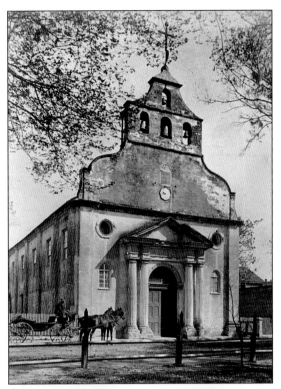

In 1797, Mariano de la Rocque designed and built the Catholic Church located on the north side of the Plaza.

Louisa Fatio was the daughter of Francis Philip Fatio, a Swiss who settled along the St. Johns River during the Second Spanish Period. When Florida was purchased by the United States in 1821, her father was one of the few Spanish subjects who declared to the new government, "I will take the oath of allegiance to the United States with pleasure." After the Seminoles burned the home Fatio inherited from her father, she moved to St. Augustine. In 1855, she purchased a boarding house, today known as the Ximenez-Fatio House, and resided there as innkeeper until her death in 1875. She can be seen in the first floor window.

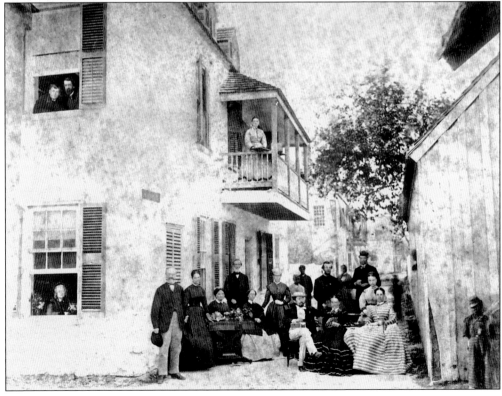

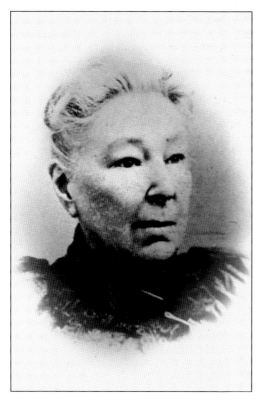

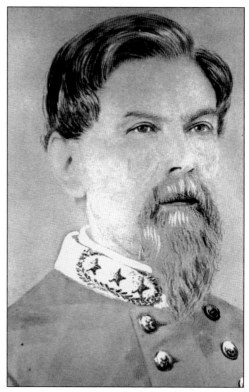

The Dummett sisters, Sara and Anna, opened a boarding house in 1845, today known as the St. Francis Inn. Both women were avid Confederate supporters. Sara married the Civil War general, William J. Hardee, (top, right) also a native St. Augustinian. Anna led a crusade to erect the Confederate War Memorial in the Plaza (bottom right.)

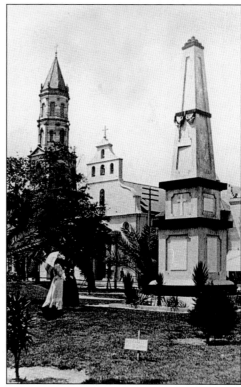

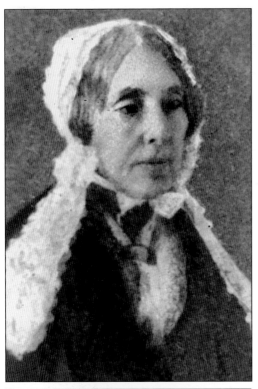

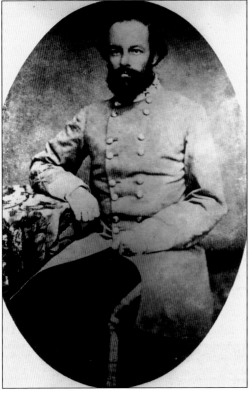

Frances K. Smith was the mother of the respected Gen. Edmund Kirby Smith, CSA (below). When the Southern states declared their loyalty to the Confederacy, Kirby Smith declared his, as well. Frances, vehemently outspoken against the Union, was banished from St. Augustine by Federal troops occupying the city. She never returned. During the Civil War, Kirby Smith commanded troops in the first Battle of Bull Run (Manasses). He was the last Confederate general to surrender after the Civil War ended in 1865.

The Smith home and birthplace of Kirby Smith was built for the Seguis family. It has seen service as the city's public library, a courtroom, and a newspaper office.

It now houses the St. Augustine Historical Society's vast archives.

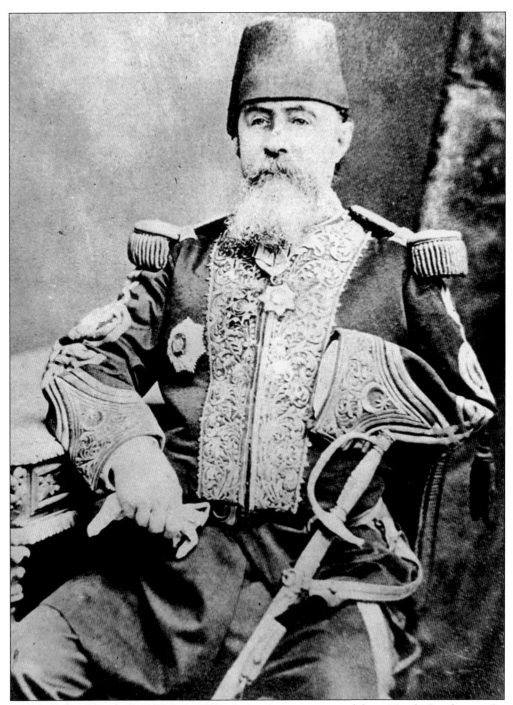

In 1823, when he was five, William Wing Loring's parents moved from North Carolina to St. Augustine to establish a boarding house. Loring became an Indian fighter at the age of fourteen, having left home to grow up alone in the wild west as a soldier in the U.S. Army. He later became a Confederate general as well as a general in the Egyptian Army. His ashes rest in the Plaza beneath a granite obelisk.

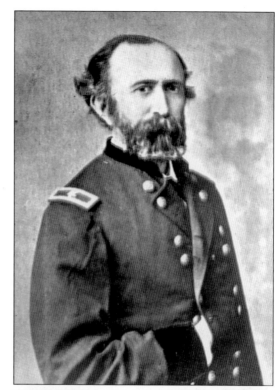

Col. Stephen Vincent Benet, a West Point graduate and a brigadier general in the United States Army in 1874, remained loyal to the Union throughout the Civil War. He was father of three noted writers, the most famous being poet Stephen Vincent Benet, who wrote *Spanish Bayonet*, a novel about the perseverance of the Minorcan community. Benet's great grandfather was Pedro Benet, nicknamed "King of the Minorcans." In 1928, Benet received a Pulitzer Prize for his book-length poem *John Brown's Body*.

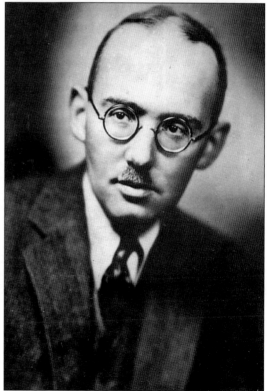

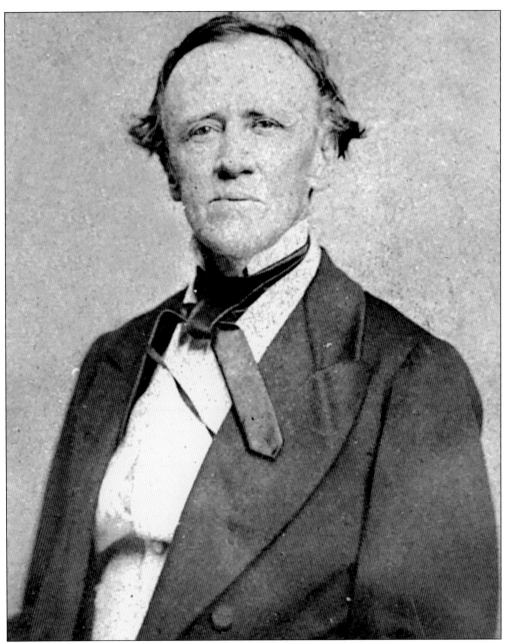

Thomas Buckingham Smith, son of Josiah and Hanna, was a multi-talented resident—planter, historian, and American diplomat to Mexico and Spain. He later assumed the role of his father, who had been a United States consul to Mexico. Smith was deeply concerned over the plight of African Americans in St. Augustine, so much so that he freed his slaves. After his death in 1871, Smith willed the bulk of his estate to the city's African-American population. The Buckingham Benevolent Trust remains in existence today.

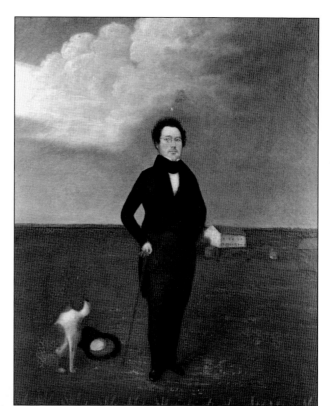

Dr. Andrew Anderson and his wife, Mary, moved to Florida in 1821. They purchased property where Flagler College is now located, planted a vast orange grove, and dedicated their time and energy to enhancing the quality of life in the city. In 1837, the Andersons began construction on Markland House. The following

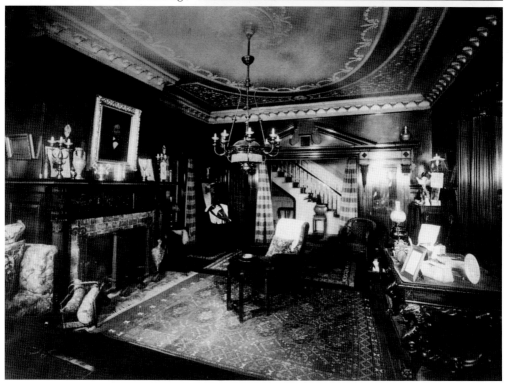

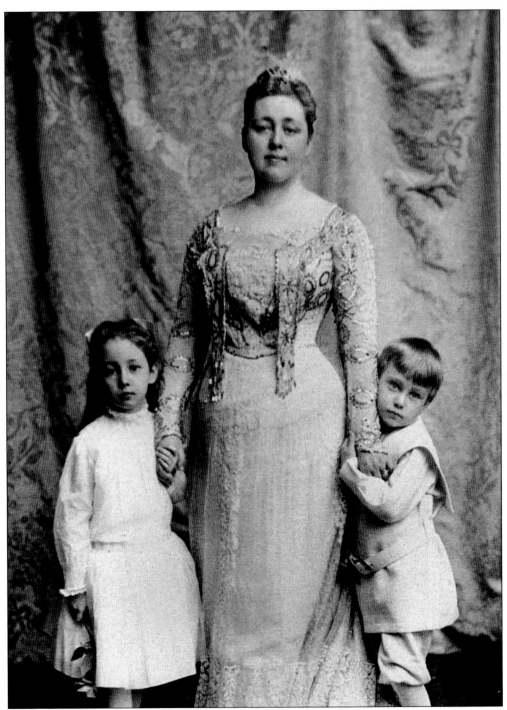

year, Mary died and, eventually Anderson married Clarissa C. Fairbanks, who raised Dr. and Mrs. Anderson's three daughters. Their son Andrew was born in 1839, several months before Anderson contracted yellow fever and died. In 1840, Markland House was partially completed so that Mrs. Anderson and her children could move in. Mrs. Anderson was known for her gracious hospitality and as a founding member of the city's prestigious Woman's Exchange.

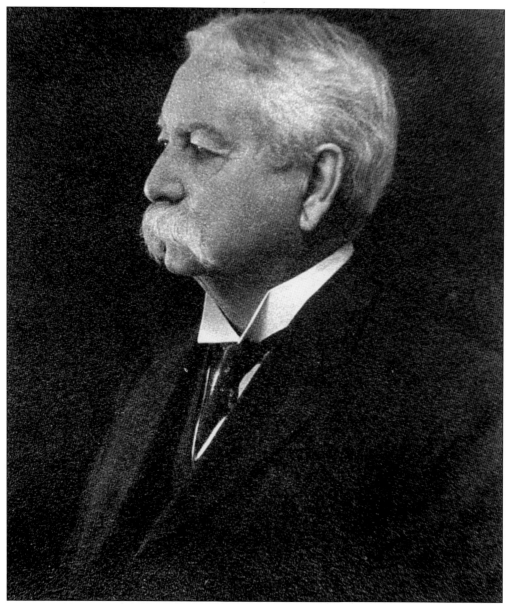

Andrew Anderson II studied medicine in the North, returned to St. Augustine to practice, and later married Mary Elizabeth Smethurst. They had two children, Clarissa and Andrew. Anderson assisted Henry Flagler in his attempt to urbanize St. Augustine.

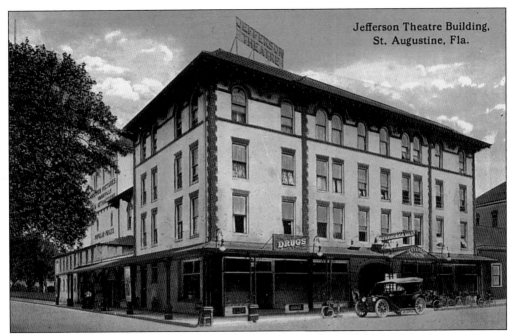

In the early 1900s, African-American women contributed to health and beauty services in St. Augustine. Ella K. Quinn, the city's popular osteopath, had her office in the old Jefferson Theatre Building.

Beloved African-American physician, D.W. Roberts, was instrumental in saving numerous lives during the 1918 influenza outbreak.

In the 1870s, Abbie M. Brooks began wintering in St. Augustine. Before her death in the city in 1914, she had established herself as a permanent resident. She also authored the travel book, *Petals Plucked from Sunny Climes*, published in 1880 under the pseudonym Silvia Sunshine. She traveled to Spain where she helped transcribe numerous original documents dating from 1500 to 1810. That manuscript, which was divided into five volumes, was later sold to the United States Library of Congress. Brooks also wrote *The Unwritten History of Old St. Augustine*.

From the late 1880s to the early 1900s, Anna M. Marcotte edited St. Augustine's society paper, *The Tatler*. She kept the city informed as to the goings and comings of the town's elite seasonal residents. Marcotte, who conveniently lived near Henry Flagler's Hotel Ponce de Leon, contributed generously to our knowledge of lifestyles and living conditions in St. Augustine during the Flagler Era.

Richard Aloysius Twine is the first known African-American photographer in St. Augustine to record the everyday events of the lives and livelihoods of Lincolnville's culture. Twine's work spanned the years from 1922 until 1927, when he relocated to South Florida. He had a keen eye for detail, contributing much to the enhancement of knowledge and understanding of the African-American race.

Twine's neighbors in Lincolnville, several blocks from the Plaza, were constant subjects for his photographic skills.

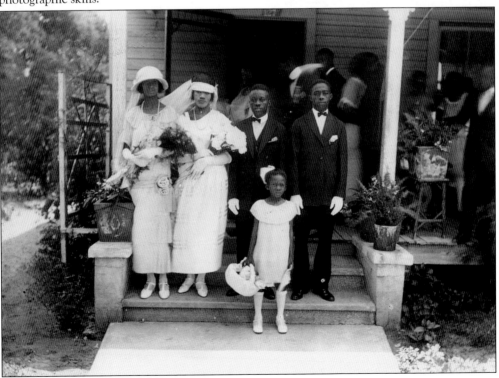

Walter B. Fraser served as the mayor of St. Augustine from 1934 until 1942. During his tenure, he was instrumental in promoting the town as a tourist attraction. He secured funds from the City, Carnegie Institute, Washington, D.C., and the Federal WPA to finance historical surveys, archaeological digs, and research. Due to his diligent efforts, the Florida Legislature passed a 1937 act giving St. Johns County and its cities the right of eminent domain in order to protect its historical structures and sites, including the controversial Fountain of Youth pictured above.

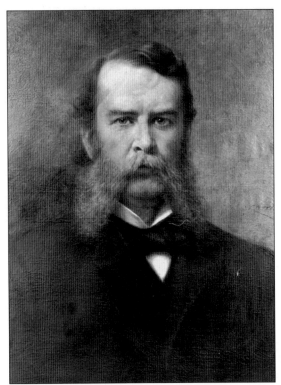

William G. Warden was an associate of Henry Flagler's at Standard Oil and a St. Augustine developer. He built Castle Warden (below), which eventually became Ripley's *Believe It or Not! Museum.* In 1925, Warden's daughter, Elizabeth Ketterlinus, donated land to the school board for a public school, later named in her honor.

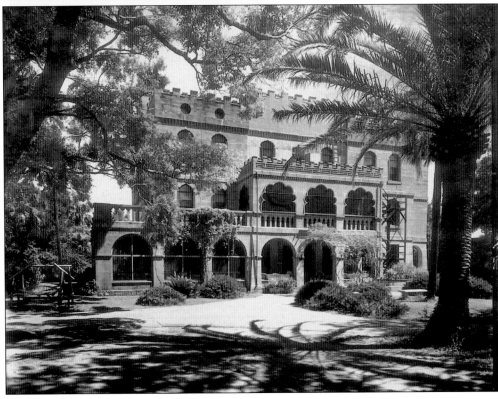

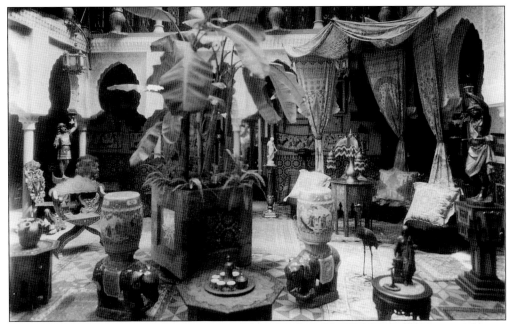

Franklin W. Smith of Boston, hardware merchant, founder of the YMCA, and amateur architect, followed Henry Flagler to town in the 1880s. He constructed the Moorish-style house on King Street, known as the Villa Zorayda, one of the first all concrete buildings in America. He then constructed the Hotel Casa Monica across from the Hotel Ponce de Leon, but within a year sold it to Flagler.

Louis A. Colee founded the St. Augustine Transfer Company in the 1880s, answering a need for carriages to deliver Henry Flagler's guests to his grand hotels. The company continues in existence today as sightseeing buggies for St. Augustine's thriving tourist industry.

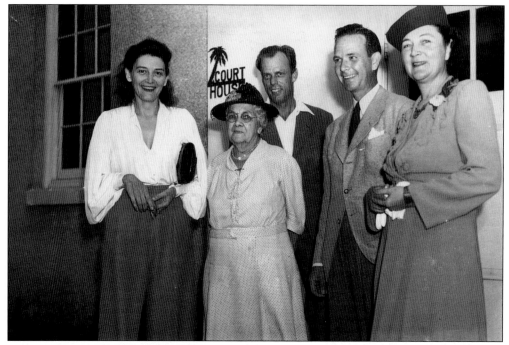

Marjorie Kinnan Rawlings, the 1939 Pulitzer Prize winner for *The Yearling*, moved to Cross Creek, Florida from New York in the 1920s. She became a resident of St. Augustine when she married Norton Baskin in 1941. Norton and Rawlings are pictured, at the far right, on their wedding day outside the St. Johns County Courthouse.

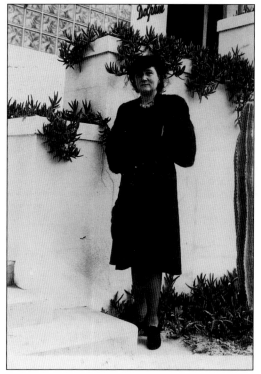

That same year, they purchased Castle Warden so that Baskin could operate it as a hotel and restaurant. The Baskins lived in a penthouse above the hotel and at their Crescent Beach house south of St. Augustine. In 1946, they sold the hotel and moved permanently to the beach, where Baskin managed the Dolphin Restaurant at Marineland. Rawlings, author of eight books, was an eccentric character, beloved by many while berated by others. In 1953, at the age of 57, she died at Flagler Hospital in St. Augustine. Baskin died in 1998 in St. Johns County. Both are buried in a cemetery near Rawlings' inspirational Cross Creek community.

Albert Manucy, a Minorcan descendant and St. Augustine native, was born in 1910 within a stone's throw of the ancient Castillo de San Marcos. As a child, Manucy played among the crumbling walls of the fort and wandered the streets of town immersing himself in Spanish history. After graduating from college, he was hired by the Federal Writers' project where he published a 1937 guidebook, *Seeing St. Augustine*. That year he also became an historian for the Carnegie Institution and a member of Walter Fraser's new committee, the St. Augustine Historical Preservation and Restoration Association. The following year, he became an historian for the National Park Service. His numerous publications, including *Houses of St. Augustine, 1565–1821* and *Sixteenth-Century St. Augustine, The People and Their Homes*, broadened scholarly interpretation of Spanish San Agustín, its art, history, architecture, and culture. Manucy's death in 1997 created a void in scholarly historic research and the preservation of St. Augustine's historical sites.

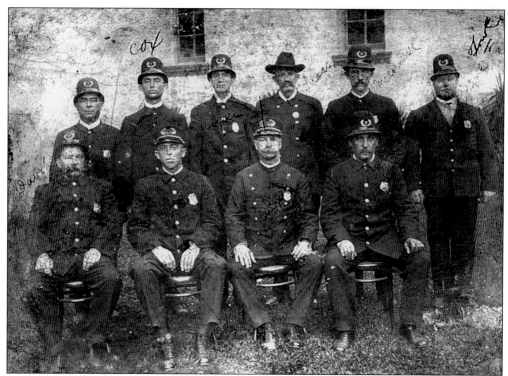

Unsung and unknown heroes worked in St. Augustine to protect the town against crime.

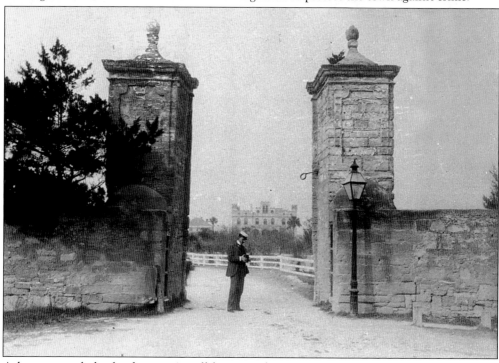

A lone sentinel checks the town's well being at the city gate. Castle Warden can be seen in the background.

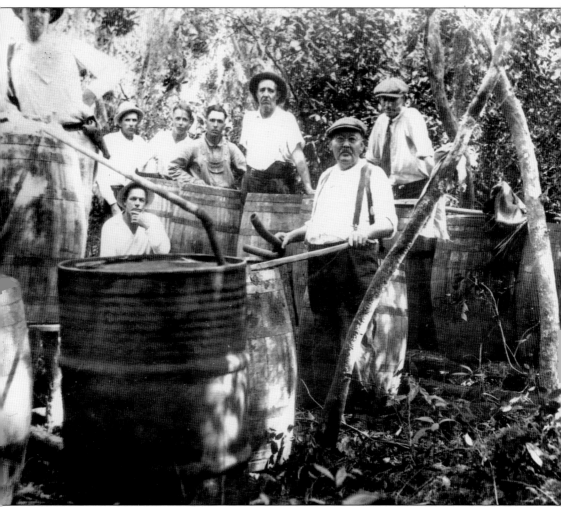

A few permanent residents were not honest, especially in the 1920s and early 1930s when prohibition slammed shut the doors of drinking parlors and saloons across America. Bootleggers carried on their clandestine activities deep within Florida's forests. Speakeasies cropped up in the most unusual places, even homes of reputable citizens. It became the challenge of Federal revenuers to hunt down and destroy this crude industry and its equipment—stills bubbling with often contaminated liquid waiting to be poured into crocks and jars for secret distribution. During the 1950s and 1960s, a reproduction of a moonshine still was a popular tourist attraction south of St. Augustine on Florida's famous coastal highway, A1A, where today a plush housing development has demolished any evidence of the once thriving and unlawful industry that operated by the shining light of the moon.

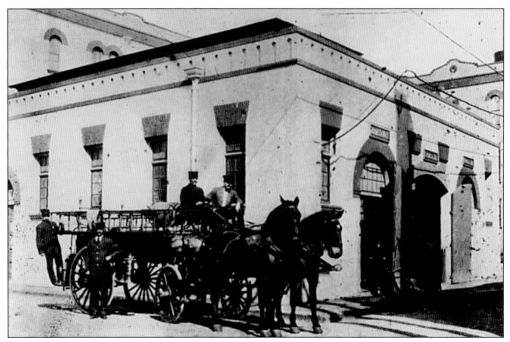

St. Augustine's fire department was always alert for the fearful spark that would ignite the town's frame buildings. At a moment's notice, the men and modern equipment were on the scene. Sometimes they were successful; sometimes they were not.

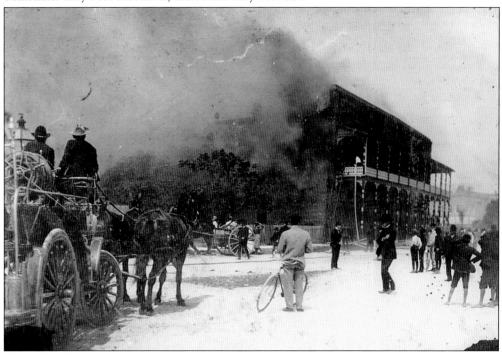

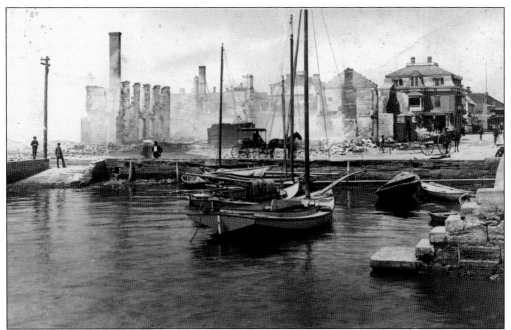

These 1887 photos show the destruction of the fire that started in the St. Augustine House Hotel. The Cathedral was lost during this conflagration. The most disastrous fire, however, occurred April 2, 1914, beginning in the frame Florida House Hotel. The *St. Augustine Record* reported, "Sweeping from St. George Street between Treasury and Hypolita, a wide swath through the heart of the city . . . caused heavy damage . . . estimated at $750,000. . . . But for heroic work, the entire section from Cordova to Bay and from Cathedral Place to the City Gates would have been lost."

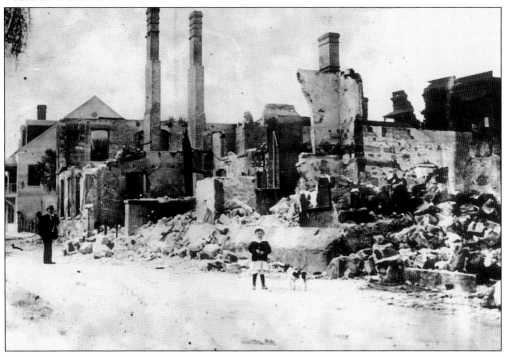

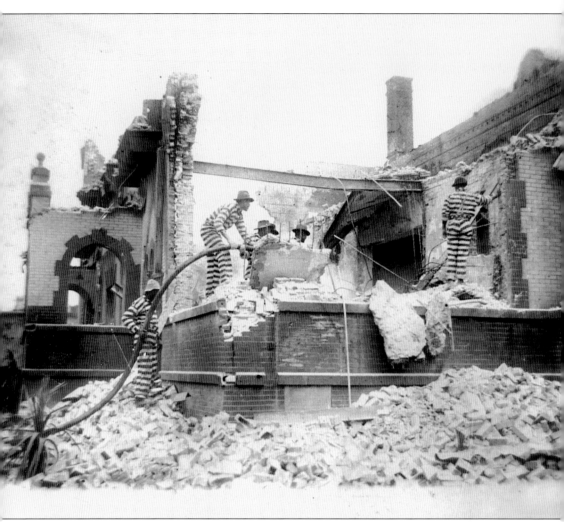

Years ago, Florida adopted the philosophy that prisoners should earn their keep—thus the State initiated the "chain gang." Chain gang members cleaned roadways and assisted in numerous other public projects while wearing a long chain around their ankle to which a large steel ball was attached. When they walked, they had to carry the ball or drag it behind them. Occasionally shackles were removed from trusted prisoners. Evidently the prisoners assisting the professional fire fighters in dousing the 1914 city fire were "trustees" as there is no evidence of the ubiquitous ball and chain.

St. Augustine had its teachers, beginning with a Catholic priest during the First Spanish Period. In the Second Spanish Period, priests established a free school. White males were required to attend. It was optional for male African Americans.

In the 1860s, the Sisters of St. Joseph, a Catholic order from France, opened a school for boys and girls of former slaves. Girls were taught home survival skills rather than the typical educational program offered to their male counterparts.

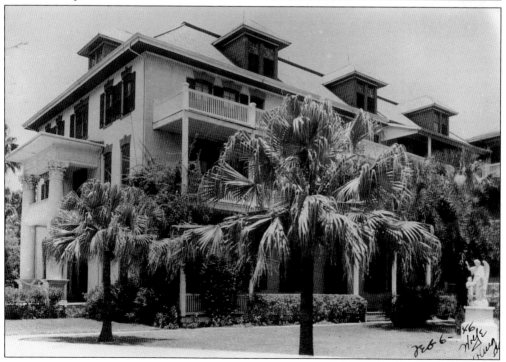

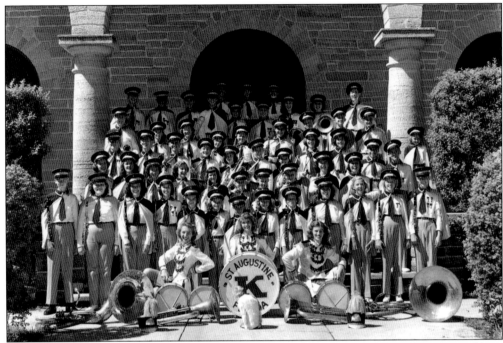

Students marched through the educational system in St. Augustine. They read, wrote, and kept time to the music, even took a break to pose on the steps of the WPA constructed Civic Center.

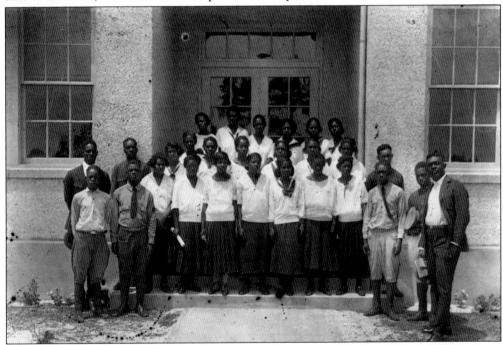

Students also posed with classmates so noted local photographer, Richard Twine, could capture their images outside the Florida Normal and Industrial Institute. Later named Florida Memorial College, the campus was located on the Tocoi Road west of town. When the college moved to South Florida, the complex fell into decay.

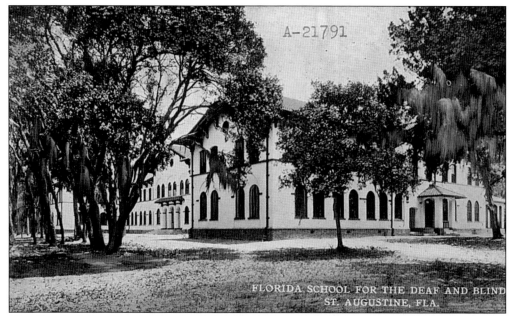

The Florida School for the Deaf and the Blind was established in St. Augustine in 1885 and attended by such notable musical contemporaries as Ray Charles and Stevie Wonder.

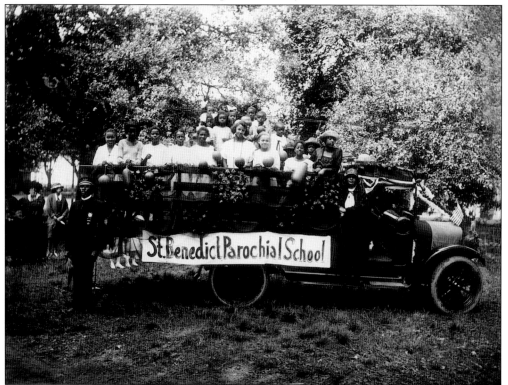

Hundreds of unnamed educators guided the destiny of thousands of permanent St. Augustine residents. Their deeds are forgotten, yet in the lives of those who led the ancient city forward, those notable heroes and their teachings live on.

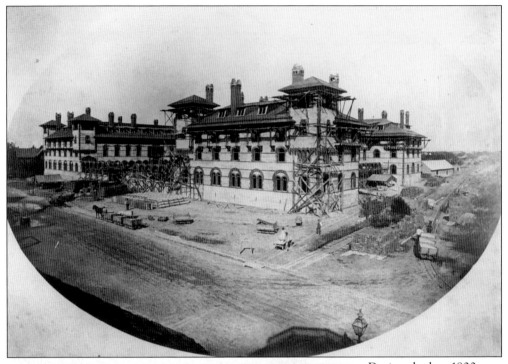

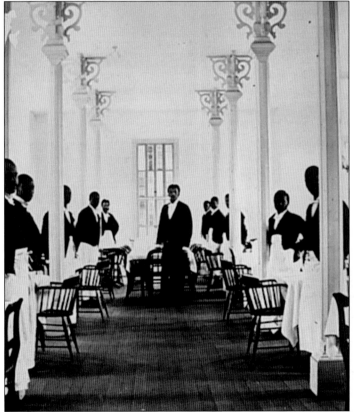

During the late 1800s and early 1900s, numerous permanent residents assisted Henry Flagler in building his sumptuous palaces and then catering to the needs of those who spent "the season" in residence. The gracious Hotel Ponce de Leon was built in the heart of the old city on the site of what had been Andrew Anderson's prized citrus grove. Harper's *New Monthly Magazine*, in March 1893, advertised that "[with] the Flagler group of St. Augustine hotels . . . cost is not uppermost in the minds of those who spend much time in them."

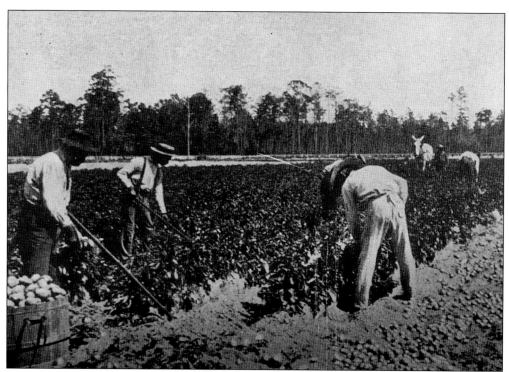

Local agriculture took a serious turn toward the commercial when Flagler established outlying farms to grow produce for his hotel kitchens.

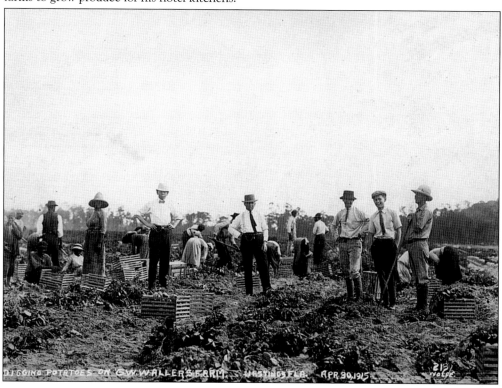

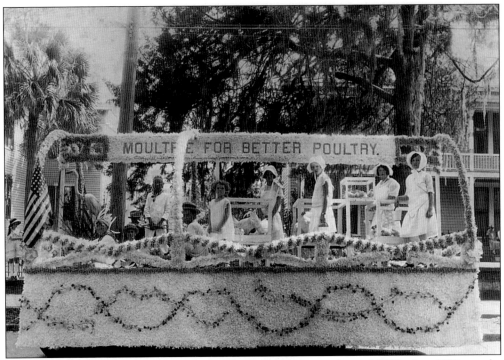

The poultry industry thrived through the Flagler Era and into the mid 1950s. In a 1927 parade, it even bragged publicly about its production—Moultrie For Better Poultry.

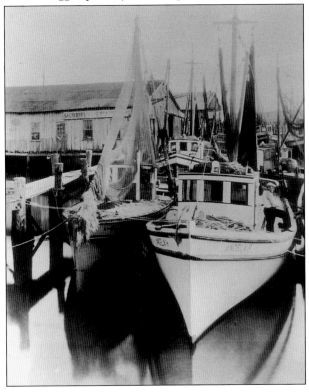

Residents were fed deliciously fresh seafood thanks to the initiation of the shrimping industry by Italian immigrants.

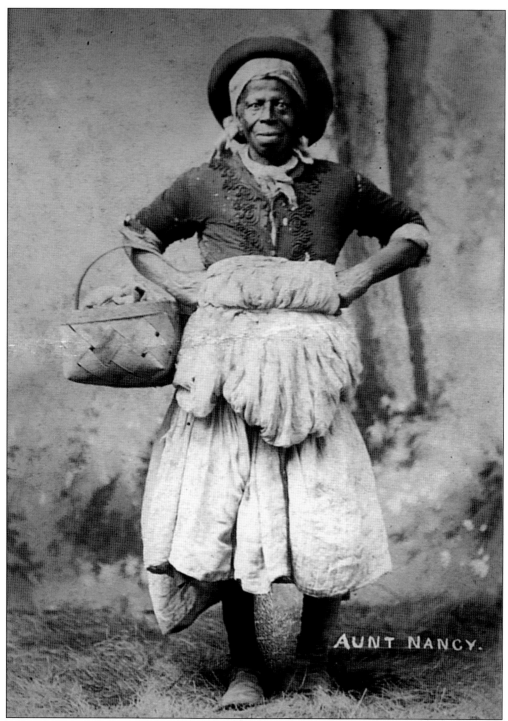

Aunt Nancy offered fresh produce along the dusty city streets.

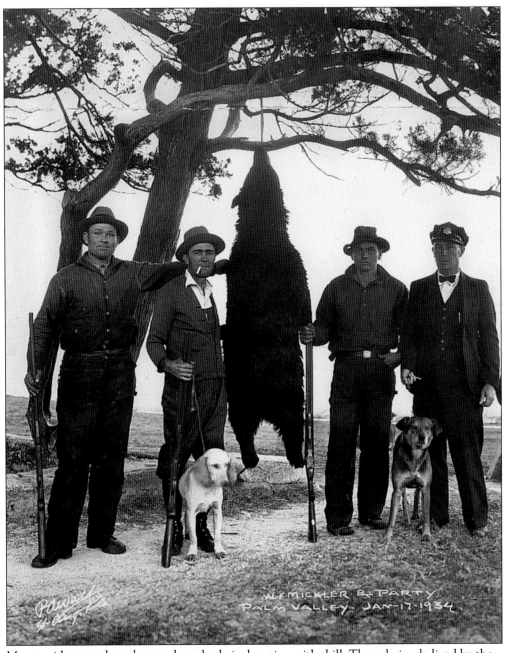

Many residents took to the woods to do their shopping with skill. They obviously lived by the creed that "man provideth the meat"—quite literally.

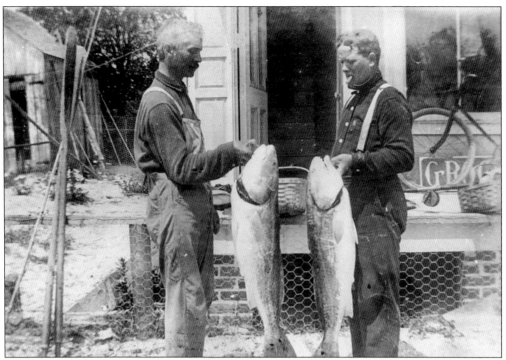

Others took to the water for fish and turtles.

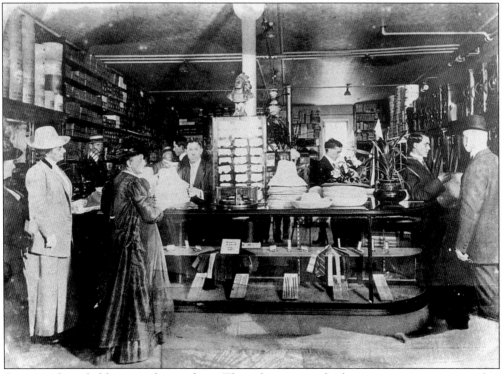

Some residents led luxuriously easy lives. Their shopping took place in attractive stores with a wide selection of items offered by the H.W. Davis Store *c.* 1894.

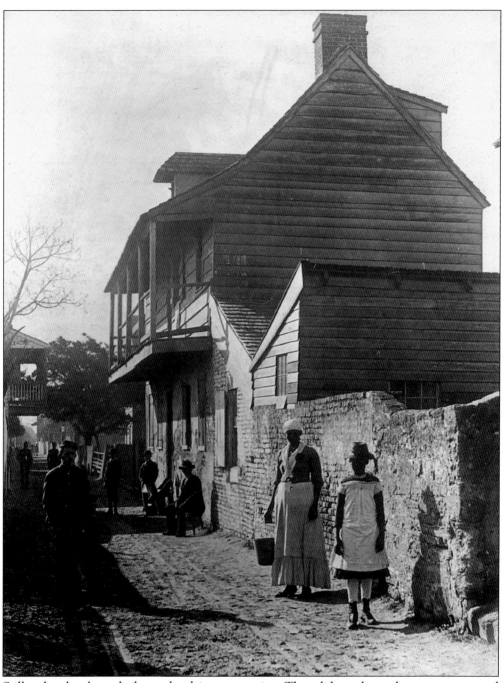

Still, other locals worked very hard just to survive. They did not have the means to spend endless hours shopping. They made what they wore, built what they needed, and grew what they ate.

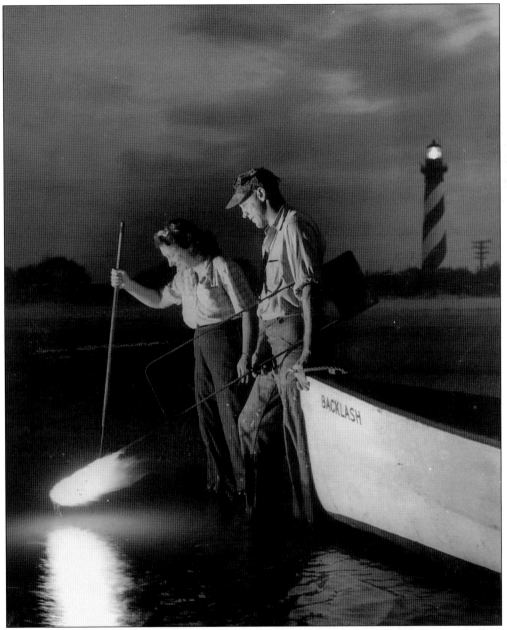

Gigging for flounder along the shore of Salt Run by lantern and moonlight was a thrilling pastime. Noted author and cook Marjorie Kinnan Rawlings searches for a table delicacy.

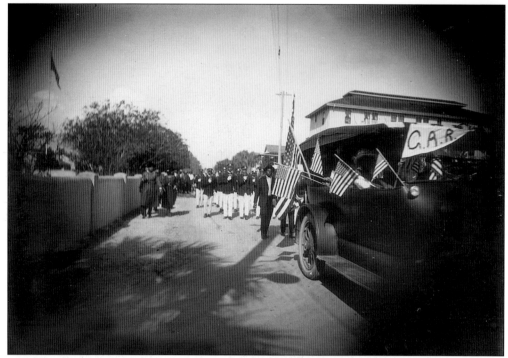

St. Augustine's citizens marched exuberantly in celebration of Emancipation Day.

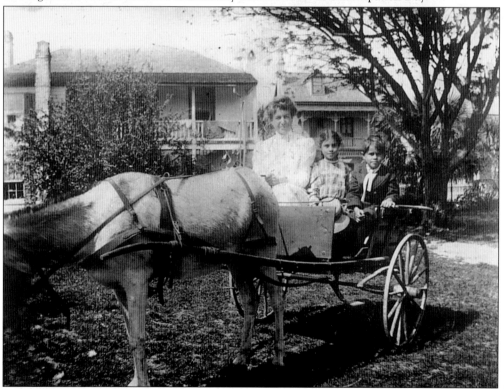

They rode about town in a donkey cart.

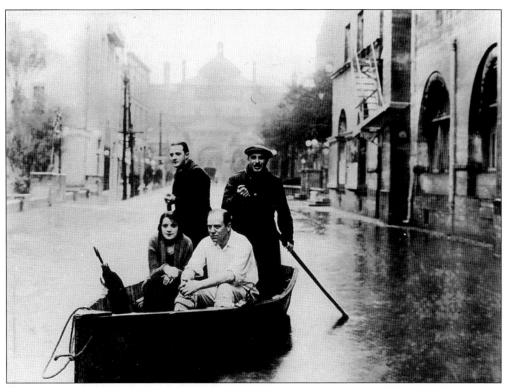

When streets flooded, clever St. Augustinians kept afloat on downtown thoroughfares.

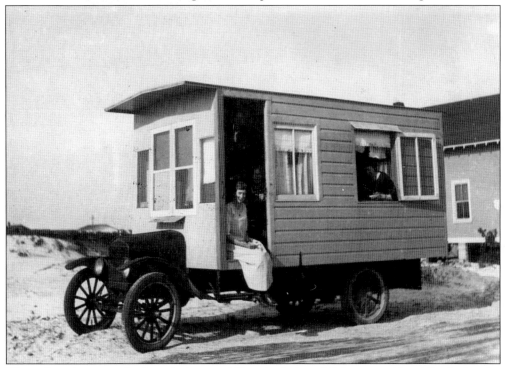

Then when the season beckoned, they would hop in their mobile home and head for the beach.

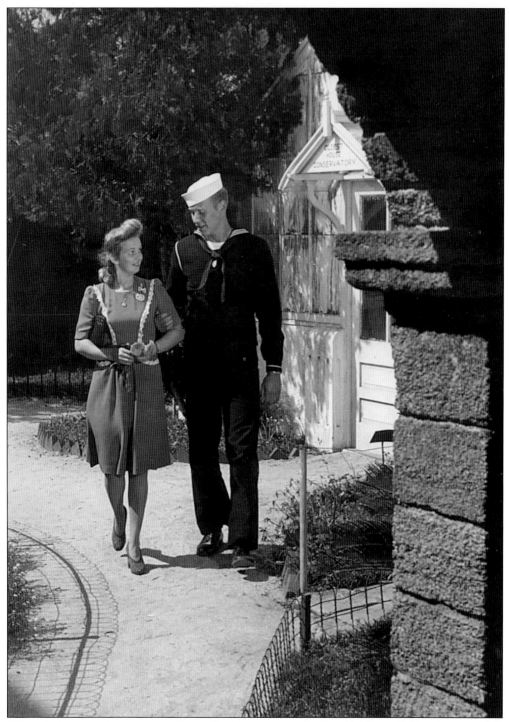

Often during quiet hours, young lovers found a moment to enjoy the beautiful landscape or bid each other a solemn goodbye.

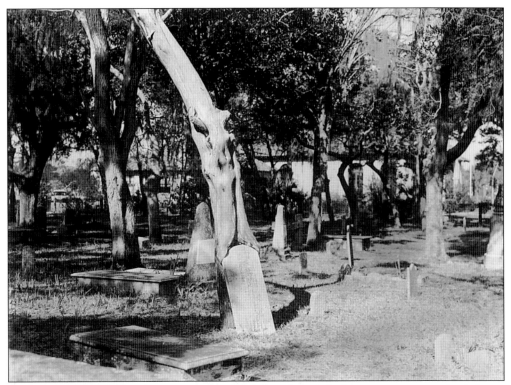

For many who built St. Augustine, who lived, loved, and died in town, a gravesite is but a reminder of their existence. Tombstones in the Huguenot Cemetery near the City Gate provide the only evidence of once productive citizens.

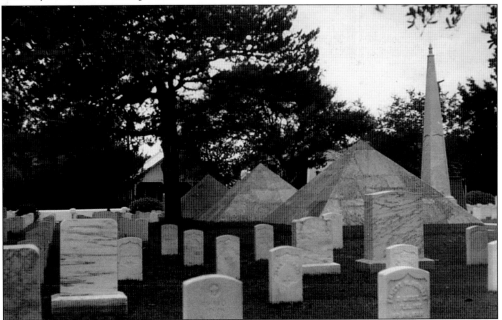

The National Cemetery on Marine Street offers the names of those permanent residents who gave up their lives that we might remain free.

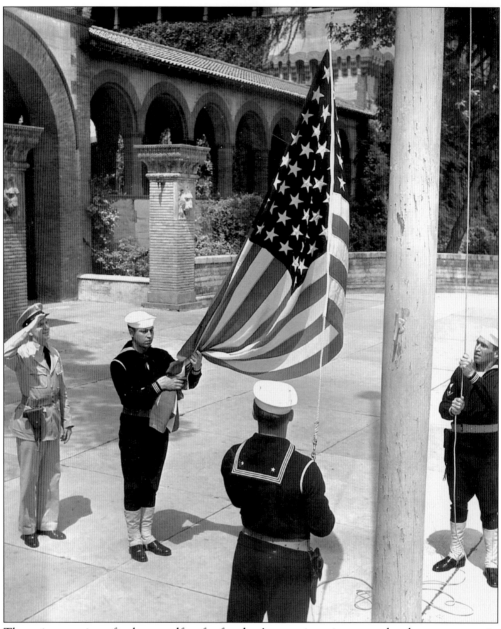

The poignant view of valor, steadfast for freedom's way, gives rise to our loyalty as our men in uniform raise America's flag in front of the historic Hotel Ponce de Leon. As they salute this symbol of democracy, we salute their existence—past, present, and future. We give honor to their commitment to defend us and we applaud their efforts. As they protected us, we protect and cherish their memory.

To all of St. Augustine's departed souls, we thank you for having been.